BARKLEY L. HENDRICKS

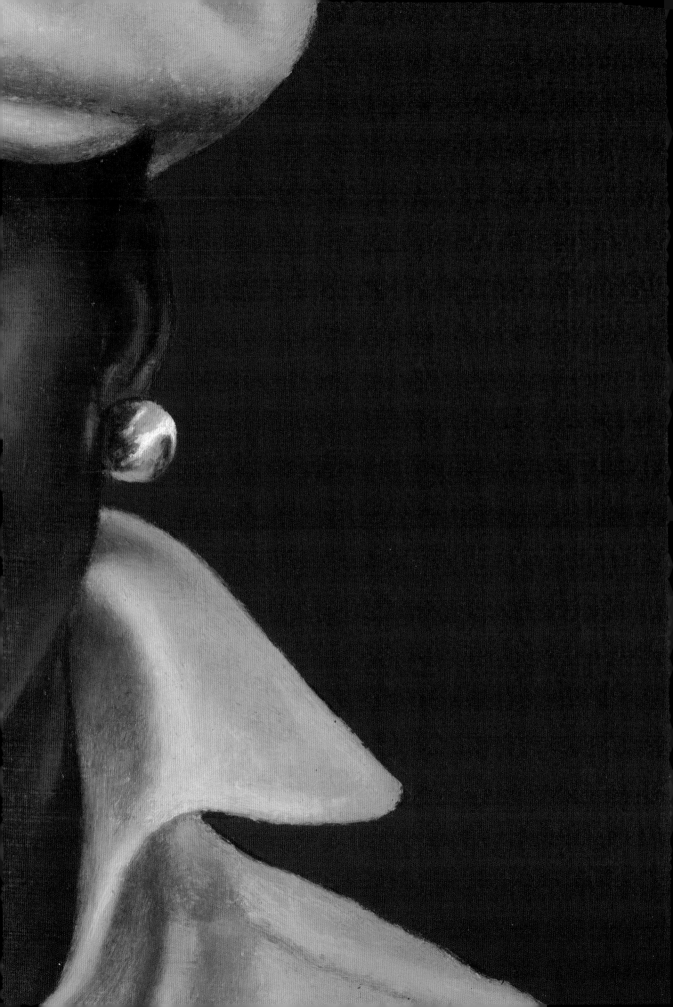

BARKLEY L. HENDRICKS

Aimee Ng
Antwaun Sargent

Foreword by
Thelma Golden

With contributions from
Derrick Adams

Hilton Als

Nick Cave

Awol Erizku

Rashid Johnson

Fahamu Pecou

Mickalene Thomas

Kehinde Wiley

PORTRAITS AT THE FRICK

Rizzoli|Electa THE FRICK COLLECTION

CONTENTS

Catalogue

ENTRIES BY AIMEE NG

Reflections

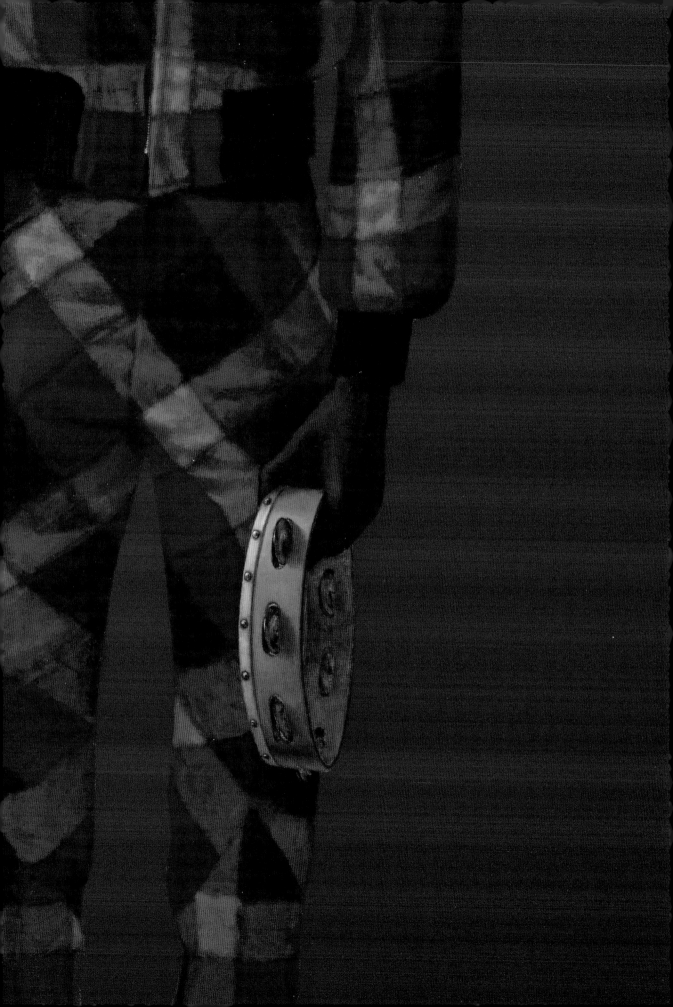

Real Cool: Barkley Hendricks at the Frick

THELMA GOLDEN

I can think of no better addition to the Frick's inspired initiative to show contemporary art within the context of its own historical collection than the work of renowned painter Barkley L. Hendricks, a pioneer of twentieth-century portraiture and keen observer of Black life. Though he painted his contemporaries, Hendricks studied and revered the Old Masters. He was a fan of Jan van Eyck in particular, and you can see the Flemish painter's grandeur, flatness, and light in the religious manner with which he renders the full-length and bust portraits of his family, friends, strangers, dandies, and himself. His paintings are astute, slick, and lush—effortlessly cool. *Barkley L. Hendricks: Portraits at the Frick* shows us that through his revolutionary use of color and technique, Hendricks elevates his everyday subjects to a place worthy of the divine.

In 2008, the Studio Museum in Harlem was honored to be one of four institutions to host Hendricks's first career retrospective. Organized by the Nasher Museum of Art at Duke University and curated by Trevor Schoonmaker, *Barkley L. Hendricks: Birth of the Cool* included works from more than forty years of an illustrious but underrecognized career. Years before, when I was a young curator researching my exhibition *Black Male* at the Whitney Museum of American Art, Hendricks's work fit precisely within a show that addressed and examined Black masculinity from all angles. The artist worked in a form of realism that was not aloof; his chic subjects confront their viewers head-on, wearing their individualism proudly, if not self-importantly. At the time, I was interested in the overlap among representations of race in our social fabric, art's

place in popular culture, and historical art, a line that Hendricks so deftly walked in all his singular portraits. His figurative work is at once vernacular and extraordinary, part of the times and beyond them, serious and droll, satirizing oppressive genres and adapting them into his own.

Hendricks is the first artist of color to have a solo exhibition at the eighty-eight-year-old museum, currently located at Frick Madison. Paintings such as *Northern Lights* (1975) and *APB's (Afro-Parisian Brothers)* (1978) are interwoven with works in the Frick's collection, an arrangement that not only juxtaposes the artist with his art-historical forebears, such as Van Eyck, but also illustrates that Hendricks has always been in conversation with better-known, white painters from the canons of realism and portraiture. This inclusion is a way of amending centuries of art history and thus opening up new possibilities for more complete histories to come.

Included in the exhibition is one of the Studio Museum's prized works: *Lawdy Mama* (1969). This painting appears medieval in its iconography: brazen gold leafing offsets an austere portrait of the artist's cousin, who wears her hair in a gorgeous afro resembling a halo. That the artist used gold leaf, a medium historically reserved for portraits of saints and gods, speaks to his commitment to placing Black subjects within the artistic canon, avowing that friends, family, and everyone in between are worthy of veneration. Working in figuration when abstraction was in vogue, taking inspiration from Renaissance painters from the fifteenth and sixteenth centuries amid twentieth-century counterculture, and painting Black individuals he met on the street wearing, for example, a fabulous knee-length, green leather coat trimmed in fur, Hendricks stood out in the East Coast milieu of the 1960s. Now, four decades after he painted *Lawdy Mama*, Barkley L. Hendricks has achieved what may have been his most inspiring goal: to place Black bodies at the iconic level. As the Frick was one of his favorite museums, I'm certain he'd be pleased with the inspired context.

Thelma Golden
Director and Chief Curator
The Studio Museum in Harlem

Director's Preface

Barkley Hendricks admired the Old Masters yet resolutely followed his own vision and reflected his own time. In the late 1960s, he drew from and challenged traditions of European art, focusing on portraiture when abstraction dominated artistic agendas. That The Frick Collection was one of his favorite museums is perhaps unsurprising, given the strength of its portraits. Fifty years on, representation of individuals and issues of race remain a critical concern, particularly to Black artists, for whom Hendricks is today a shining example.

This is the first exhibition the Frick has dedicated to a Black artist, and the first in many years to concentrate on Hendricks's earlier portraiture. While the Frick does not collect art made past 1900, we do wish to explore with our audience the dialogue between artists practicing in the present and those who came before them. Among these projects are exhibitions of contemporary artists working with the traditional material of porcelain (Arlene Shechet, Edmund de Waal, Giuseppe Penone) and installations of younger artists exploring Queer identity alongside Vermeer, Holbein, and Rembrandt—*Living Histories: Queer Views and Old Masters*. In the current exhibition, we juxtapose the work of a Black American painter with European art from the Renaissance to the modern era. We pose the questions: What did Hendricks see in these older works and learn from them? How did he transpose these models into creations that so vibrantly reflect the world he lived in? What from Hendricks's achievement, in turn, lives on in contemporary art?

In the search for an exhibition topic, Frick curator Aimee Ng enlisted the support of the writer and curator Antwaun Sargent, who suggested this subject. Aimee and Antwaun benefited from the advice of many colleagues, whom they thank in their acknowledgments. I myself am grateful to several people. First among them is my fellow museum director Thelma Golden, who spoke with me about the subject a couple of years ago and, despite a full schedule, generously agreed to write the foreword to this catalogue. She was immediately favorable to our request for a star work from the Studio Museum in Harlem, *Lawdy Mama*.

Growing up in Durham, North Carolina, where my mother taught for twenty-five years at North Carolina Central University, I lived in a house full of art from the auctions she ran to raise money for that university's art gallery. My father taught at Duke University and was involved with its art museum, now the Nasher Museum. Over the years, I have admired the Nasher's commitment to collecting the work of

Black artists. Trevor Schoonmaker—curator, and now director, of that museum—was the driving force behind these acquisitions. Having organized the first major museum show on Hendricks, he has encouraged our exhibition and loaned a special portrait that was acquired by the Nasher on the eve of the exhibition that changed the course of Hendricks's career. Richard J. Powell, a Duke professor whom I knew decades ago as a friend of my parents, is another early writer on Hendricks's painting and has bolstered the current project. I am grateful to them both.

We are fortunate that the person closest of all to Barkley—his wife, Susan—has been enthusiastic about this exhibition from the beginning. Jack Shainman and the staff at his gallery have also been squarely behind the project and have made and helped to secure some crucial loans. We are thankful to all of the public and private collections who made it possible for us to assemble such a stellar group of the artist's work.

We are ever grateful to the institutions and individuals who funded an exhibition that breaks new ground for the Frick. Darren Walker, who has been such a forceful voice for social justice in this country, believed in the importance of this show and responded rapidly in helping to secure the Ford Foundation's major support. This catalogue is funded, in part, by Ayesha Bulchandani, to whom we are extremely grateful. We also want to thank Frick trustee Margot Bogert and her husband, Jerry Bogert; Bain Capital; Agnes Gund; the Cheng-Harrell Institute for Global Affairs; Jane Richards; Arielle Patrick; and an anonymous donor. Without the interest and commitment of these funders, the exhibition would not have been possible.

Ian Wardropper
Anna-Maria and Stephen Kellen Director
The Frick Collection

Acknowledgments

Barkley L. Hendricks's fondness for The Frick Collection led him to visit the museum nearly every time he traveled, usually with his wife, Susan, to New York from their home in New London, Connecticut, where he taught at Connecticut College from 1972 to 2010. For an artist who snapped innumerable photographs of people, places, and objects that caught his eye—using his camera throughout his career as a "mechanical sketchbook"—the Frick's strict no-photography policy in its galleries (enforced for the safety of the objects on view) must have felt limiting. There was more than one run-in with Frick security officers who eyed the cameras (sometimes up to three) he wore around his neck. And still he returned again and again to spend long days with Rembrandt, Velázquez, Bronzino, Van Dyck, and others.

This exhibition pays tribute to Hendricks's relationships to the Old Masters and to the Frick. That it is taking place in the Breuer building at 945 Madison Avenue, the Frick's temporary home during renovation of the historic house at 1 East 70th Street, is particularly poignant, for it was at the Breuer building, then the home of the Whitney Museum of American Art, that Hendricks first showed in New York and participated in his first major museum exhibition, the controversial 1971 *Contemporary Black Artists in America*. It was also on this site that Thelma Golden included three Hendricks portraits in her groundbreaking 1994 exhibition *Black Male: Representations of Masculinity in Contemporary American Art*, in

which Hendricks's paintings stood out to many visitors. (In his text in this publication, Hilton Als remembers his encounter with them in that show.)

Inspired by the Old Masters since his first trip around Europe in 1966, Hendricks has in turn inspired generations of artists, designers, and other creators. We are grateful to be able to explore his legacy in these pages through the contributions by Derrick Adams, Hilton Als, Nick Cave, Awol Erizku, Rashid Johnson, Fahamu Pecou, Mickalene Thomas, and Kehinde Wiley—all of whom are inspirations to countless others.

This exhibition and catalogue would not have been possible without the help and support of many people. First and foremost, our thanks go to Ian Wardropper, Anna-Maria and Stephen Kellen Director of the Frick, and Xavier F. Salomon, Deputy Director and Peter Jay Sharp Chief Curator, who have been steadfast in their support and have championed this show from the outset. We are grateful to the trustees of the Frick, who make it possible for us to do the work we do and support us in so many ways.

At the Frick, Curatorial Assistant Gemma McElroy worked tirelessly on this project every step of the way, from the big picture to the minutest details, and deserves our deepest gratitude. Editor in Chief Michaelyn Mitchell expertly edited the texts and managed this catalogue's many components; we are grateful to her and to Associate Editor Christopher Snow Hopkins. Trustee Ayesha Bulchandani's

eponymous curatorial internship program at the Frick made it possible for Brooke L. Finister to work on early stages of research for this catalogue in the summer of 2022; we appreciate her contributions. We extend our thanks to all of the Frick staff who worked on this project, especially Marley Amico, Tia Chapman, Joseph Coscia Jr., Allison Galea, Lisa Goble, Joseph Godla, Caitlin Henningsen, Patrick King, George Koelle, Alexis Light, Sara Muskulus, Christopher Roberson, Heidi Rosenau, April Kim Tonin, and Sean Troxell. As always, we are indebted to exhibition designer Stephen Saitas and lighting designer Anita Jorgensen and her team for bringing the exhibition to life in our galleries. The team at Rizzoli—Margaret Chace, Charles Miers, and above all, Philip Reeser—have been remarkable partners on the production of this catalogue. We thank them and the designers at Morcos Key for shaping this book with such care, innovation, and style.

The project's generous lenders agreed to share with us their treasured portraits, many of which take pride of place in private homes and public galleries. We are extremely grateful to the collectors and to the staff at lending institutions: the Studio Museum in Harlem, especially Sydney Briggs and Connie Choi; the Philadelphia Museum of Art, especially Carlos Basualdo, Alison Tufano, and Erica Battle; the Harvard Art Museums, especially Mary Schneider Enriquez and Kate Smith; the Nasher Museum of Art at Duke University, especially Julianne Miao, Wendy Hower, and Lee Nisbet; the Whitney Museum of American Art, especially Jennie Goldstein, Lawrence Hernandez, and Matthew Skopek; the Chrysler Museum of Art, especially Lloyd DeWitt and Chelsea Pierce; the Virginia Museum of Fine Arts, especially Michael Taylor, Valerie Cassel Oliver, Alexis Assam, Joshua Summer, and Sylvain Cordier; and the Yale University Art Gallery, especially Keely Orgeman, Margaret Ewing, and Andrés Garcés. Visits with curators and conservators at all of these museums have been invaluable experiences and cherished memories.

The support and counsel of scholars and curators who paved the way for the study of Hendricks have been crucial to this project. We thank especially Thelma Golden, Trevor Schoonmaker, and Richard J. Powell for their pioneering work and generosity during the preparation stages. For advice, helpful discussions, and more, we are also grateful to Esther Adler, Gannit Ankori, Andaleeb Banta, Naomi Beckwith, Kellie Jones, David Pullins, Kimerly Rorschach, Legacy Russell, and Zoé Whitley.

Key funding from the Ford Foundation was instrumental to this exhibition. The support of visionary leader Darren Walker, the foundation's president, is deeply appreciated and a point of pride. We thank Darren—a longtime friend of the Frick—for his faith in this project and for so much more.

Jack Shainman and his team at Jack Shainman Gallery have been ideal collaborators. We are particularly grateful to Joeonna Bellorado-Samuels, Isabel Hidalgo, Jarek Miller, Ruth Phaneuf, and Ellen Poile. Elisabeth Sann is both a wealth of knowledge about all things Barkley and a good friend; to her we are most grateful.

Finally, we are indebted to the Estate of Barkley L. Hendricks. With the expertise and talent of David Katzenstein and his colleagues at the photography archive, Susan Hendricks and the estate have been extremely generous in many ways, not least of which is allowing us to include in this volume many unpublished archival photographs and a very special drawing. Their inclusion has allowed for a richer understanding of Barkley's portraiture and the role of photography in his process. To Susan, especially, who has given so much to this project and endures so great a loss, we offer our deepest thanks for all of this and for the privilege of her friendship.

Aimee Ng
Curator, The Frick Collection

Antwaun Sargent
Curator and writer

Detail of cat. 4

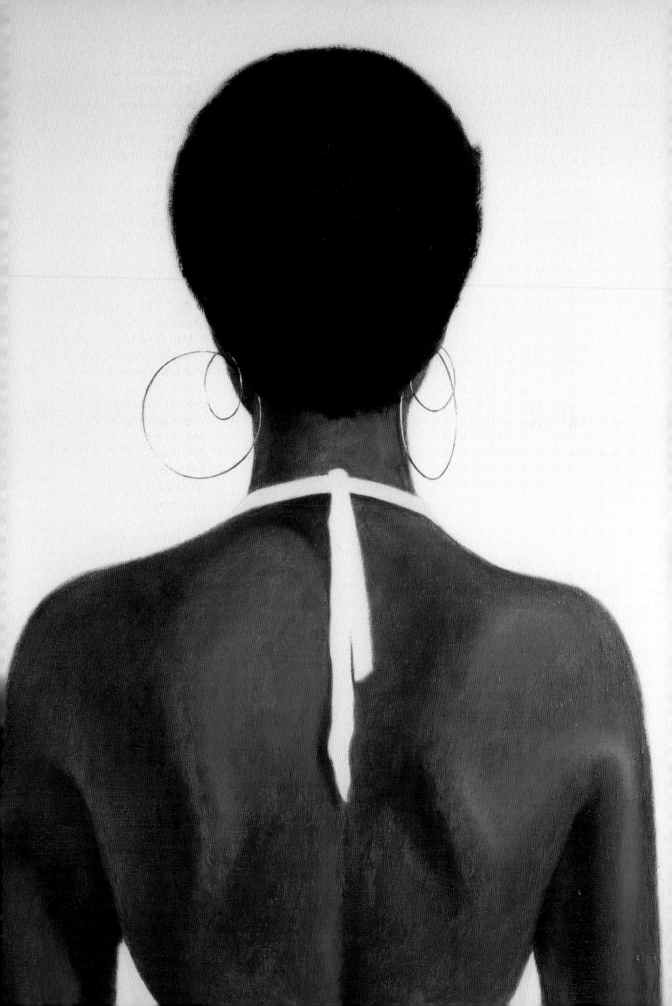

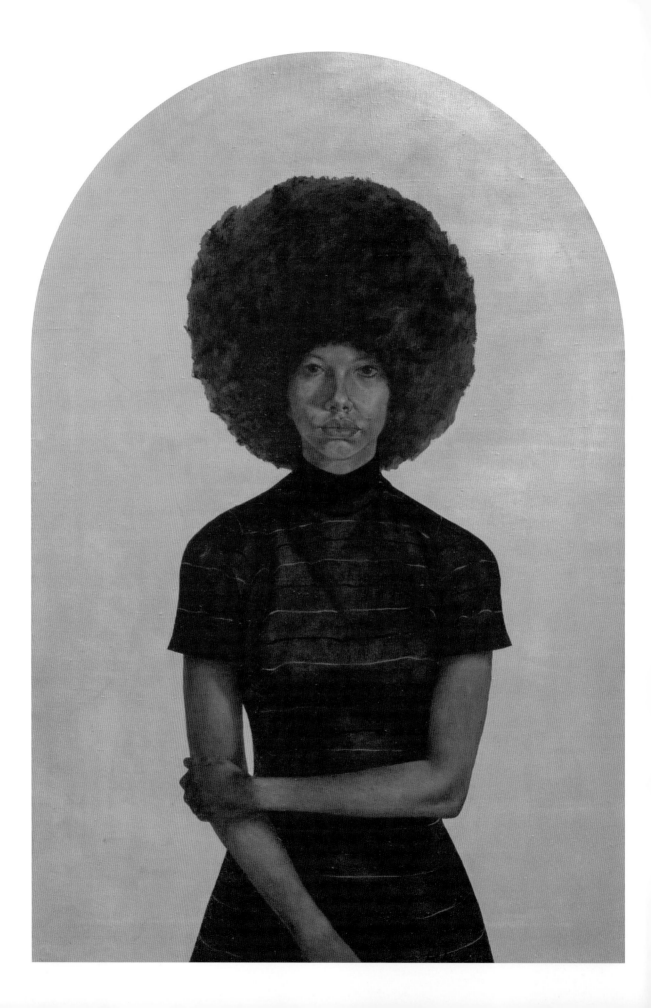

Barkley L. Hendricks and the Old Masters

AIMEE NG

*I wasn't a part of any "school." The association I had
with artists in Philadelphia didn't inspire me in any
direction other than my own. I spent my time looking
to the Old Masters.*

—BARKLEY L. HENDRICKS, 2017

During a visit to The Frick Collection in 2011, Barkley L. Hendricks
responded to a question about the absence of people of color in
Old Master paintings, like those by Rembrandt he had just seen
in the museum (fig. 1). His answer—generous, wry, and matter of
fact—suggested that one simply had to go down to the waterfront
to find them loading barges and lifting bales; Rembrandt, however,
"was dealing with the monied folks of Holland."[1] Coming through
in these remarks are Hendricks's confidence, his acceptance of the
facts of history and its undeniable injustices, and his assurance
in his own capacity to make history in his own time. It was perhaps
with the same confidence that the twenty-one-year-old artist—
touring Europe in 1966 and seeing "how limited the representation
of black figures has been in Western art history, and how few of
those depicted have been truly humanizing or personalized
portraits"[2]—marshalled the hallmarks of European artistic mas-
tery to portray people of his life and world in 1960s America. His

encounters with Rembrandt, Van Dyck, and other Old Masters—
eye to eye, artist to artist—led him to imbue his subjects, most of
them people of color, with that confidence, establishing the power,
dignity, and poise for which his portraits are known.

This publication and the exhibition it accompanies bridge
two distinct fields of art and history: early modern Europe and
America of the late 1960s to early 1980s. People will bring to them
a range of perspectives that may at times be at odds. Elements
taken for granted by some may be provocative or offensive to
others; for example, *Old Masters* remains for some a useful term,
deriving from the mastery of craft, to refer to European artists
from the Renaissance to about 1800, while for others it is outdated
and embodies sexist and imperial legacies. The positions are not
mutually exclusive; some will identify with both.[3] Individual works
of art can also elicit opposing perspectives, as, for some, historical
European paintings are pinnacles of Western achievement, while
for others they represent the atrocities inflicted upon Black and
Indigenous peoples for centuries (I have witnessed such opposi-
tions firsthand). The acknowledgment of and appreciation for
multiple and sometimes conflicting views underlies this project,
for the union of disparate worlds, the bridging of difference, is
inherent in the art of Barkley L. Hendricks.

Borrowing and emulation have long been crucial components
of artistic practice. Of course, similarities between works of art
are not always the result of imitation or derivation: sometimes,
artists solve artistic problems independently, centuries and worlds
apart, connected not by influence but by common pursuits. And
though Hendricks's engagement with historical European art is the
subject of this essay, it is important to note that he was inspired
by art and culture from around the world and across time. In the
years after his first trip to Europe in 1966, he visited Morocco,
Tunisia, Algeria, Libya, and Egypt.[4] In the late 1970s he traveled
to Africa (primarily Nigeria), and from 1980 onward he visited the
Caribbean (primarily Jamaica).[5] He was interested in many fields
of art, especially African and Indigenous art, and music, particularly
jazz. He worked in various media—including oil and acrylic paints
(occasionally Magna), watercolor and drawings on paper, collage,
sculpture, and photography—and in several themes and genres,
including basketball paintings and landscapes. Sometimes, he
even made his own frames. One critic referred to seeing "two"
Barkley L. Hendrickses when viewing his portraits alongside his
landscapes.[6] His ostensibly discrete bodies of work, some made
simultaneously alongside his most iconic portraits, testify to the
richness and versatility of his creativity. It also has historical prec-
edent. The term *Renaissance man* denotes an individual who
is skilled in many capacities, referring to artists such as Leonardo
da Vinci, who made paintings and drawings while conducting sci-
entific studies and designing machines and architecture. In many
ways, Barkley L. Hendricks was a Renaissance man.

Race is central to Hendricks's practice. Critics have not
always appreciated the audacity of his project: exalting contem-

Fig. 1
Still from a 2011 video, "Barkley L.
Hendricks on Rembrandt"; Nasher
Museum of Art at Duke University,
Durham, N.C.

porary Black figures by adapting the visual language of European Grand Manner portraiture.[7] An early reviewer dismissed the significance of race in his portraits, suggesting that "his subjects notwithstanding," referring to his Black sitters, Hendricks's works are "not political" (implying that this was a shortcoming).[8] But it was precisely who his subjects were, together with how he portrayed them, that electrified his art: at a time of significant political pressure on Black artists in America in the late 1960s and '70s, it was in some ways an act of bravery for him to join forces with the very legacies of European art and power that the Black Arts Movement sought to expose and overcome.

In these portraits, Hendricks does not picture violence, even if at times he alludes to struggles of Black Americans in his titles— for example, in the title of his early self-portrait *Icon for My Man Superman (Superman Never Saved Any Black People—Bobby Seale)* (see fig. 32). European portraits like Rembrandt's isolate affluent individuals without explicit reference to the horrors of colonization and enslavement that in many cases made their wealth possible— excepting those that include shackled or subservient Black figures—but the clues are there, in the pearls harvested from colonies in Southeast Asia, beaver-felt hats from colonies in North America, and the very material of mahogany panels, from colonies in the Caribbean and Central and South America, on which some European portraits are painted. Hendricks's portraits, too, focus on his subjects' dignity, stylishness, and individuality, with more layers and complexity than may at first meet the eye.[9]

This subtlety contrasted somewhat with the artistic culture around Black subjects in the late 1960s and '70s. Of the art of this moment, Hendricks remarked:

> How many black people . . . were part of any kind of visual information that didn't deal with what I call the misery of my peeps? You know, you can always find visual information that deals with the hardship, slavery, and all the rest of it. I'm not denying any of this by any stretch of the imagination, but I'm trying to sort of address a situation that's not a part of that.[10]

He chose to highlight the "beauty, genius, skill" of Black people "that's a part of what we've brought to America and the world that doesn't get addressed the way that I feel it could."[11] It is only relatively recently—about 2008, when Trevor Schoonmaker mounted the *Birth of the Cool* exhibition at the Nasher Museum of Art in Durham, North Carolina, which traveled across the United States— that Hendricks's project has come to be embraced widely. His work was not part of a movement, nor was he part of any "school." His singularity was a feat of boldness and independence that paved a path for subsequent artists to pursue in their own ways.[12] Hendricks's portraiture is about legacy and what one does with it. His legacy is explored in Antwaun Sargent's essay and is honored in the contributions by contemporary artists in this volume.

Portrait is used throughout this text to refer to Hendricks's figural works. While it is beyond the scope of this essay to explore the complex definitions of portraiture in Western art, the term is used here in its most expansive sense of capturing a particular person's likeness or some aspect of identity, acknowledging that some of the figures were strangers to Hendricks, their names unrecorded, and some were invented figures (such as the nude woman in *What's Going On* [see fig. 39], whose body was modeled after a friend while the head was not).[13] This aspect of Hendricks's art too has historical precedent, for example, in Michelangelo's *teste divine* ("ideal heads," invented figures representing ideals of beauty) and Rembrandt's *tronies*—imaginative portrayals of figures dressed in fanciful and "exotic" dress—and offers yet another layer in the artist's rich creative production.

The Model Book of History

In the spring of 1966, in his third year at the Pennsylvania Academy of the Fine Arts, Hendricks won a scholarship that funded travel in Europe, as well as tuition for the next year.[14] Visiting museums in Italy, France, the Netherlands, Britain, Spain, Turkey, Luxembourg, Belgium, and Greece over a three-month period, he returned to Philadelphia with "a head full of inspirations."[15] The impact on his painting was direct, though his response was decidedly not pure imitation. He recounted a foundational experience at the National Gallery in London:

> Many museums allow students, would-be painters and aspiring artists to paint copies from in front of the originals. I was struck by a Van Dyke [*sic*], so much so I thought I would also try to do a copy of that painting. . . . While en route to get supplies, I was hit with a jolt from my creative epicenter. "I cannot copy another artist's image, no matter how much I like it," I said to myself. Seven years later, I painted a large canvas of a man wearing a long red coat [see fig. 9]. The red coat in the Van Dyke [*sic*] was the initial inspiration and theme for my painting. It had to be done Barkley Hendricks style— no copies.[16]

Byzantine icons and gold-ground Italian Renaissance paintings (such as fig. 2) inspired his groundbreaking *Lawdy Mama* (page 18 and cat. 1), for which he learned the centuries-old (and painstaking) technique of applying gold leaf.[17] In late medieval and Renaissance Italy, gold leaf was often made by hammering gold coins (produced using standard measures of purity and quantity) into thin sheets. Thus for their earliest viewers, primarily Christian worshippers, these paintings were extremely opulent—in a sense, made of money. In their sacred context, the gold signifies the divine, conveying through material splendor the importance

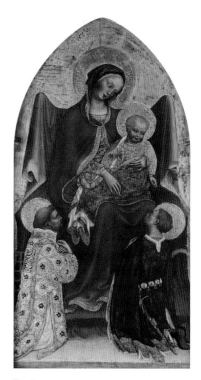

Fig. 2
Gentile da Fabriano, *Madonna and Child, with Saints Lawrence and Julian*, 1423–25. Tempera on panel, 35¾ × 18½ in. (90.8 × 47 cm). The Frick Collection, New York; Purchased by The Frick Collection, 1966

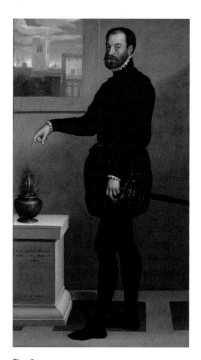

Fig. 3
Giovanni Battista Moroni, *Ritratto del Cavaliere Pietro Secco Suardo*, 1563. Oil on canvas, 72¹/₁₆ × 40¹⁵/₁₆ in. (183 × 104 cm). Gallerie degli Uffizi, Florence

Fig. 4
Barkley L. Hendricks, *J.S.B. III*, 1968.
Oil on canvas, 48 × 34⅜ in. (121.9 × 87.3
cm). Pennsylvania Academy of the Fine
Arts, Philadelphia; Gift of Mr. and Mrs.
Richardson Dilworth

of the devotional objects, while the reflective surfaces offered a contemplative visual space for the worshipper/viewer. The rounded top of *Lawdy Mama*'s canvas (crafted by Hendricks himself) echoes the perfect geometry of Renaissance art and architecture, then thought to mirror the perfection of the divine, and eloquently frames the sitter's afro-as-halo. The painting's title is taken from Nina Simone but also evokes the traditional Christian "Lord" and "Mother" (as in "Lord God" and "Mother Mary").[18] Together, these elements transmute what might otherwise be seen simply as a modern portrait of Hendricks's relative into a profound meditation on past and present, with a characteristic touch of humor. Hendricks would continue to use gold, silver, and other metallic leafing in his paintings for years.

Among those whose work Hendricks encountered during his first trip to Europe was a sixteenth-century artist with whom he would have a lifelong fascination: Giovanni Battista Moroni. Not included in Giorgio Vasari's influential canon of artists (first published in 1550 and in an expanded edition in 1568), Moroni spent his life in and around Bergamo, in Lombardy, painting portraits of the local elite, whose clothing may seem to anticipate the sensational styles of Hendricks's sitters. Moroni's *Man in Pink* (Palazzo Moroni, Bergamo), for example, which Hendricks may or may not have seen, offers a historical antecedent for the vibrant pink suit of Hendrick's full-length *Photo Bloke* (see fig. 37).

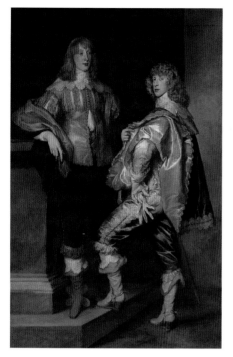

Fig. 5
Anthony van Dyck, *Lord John Stuart and His Brother, Lord Bernard Stuart*, ca. 1638. Oil on canvas, 93½ × 57½ in. (237.5 × 146.1 cm). National Gallery, London; Bought, 1988

Fig. 6
APB's (Afro-Parisian Brothers) (cat. 13)

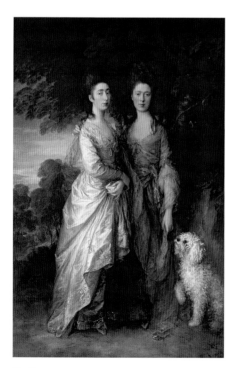

Fig. 7
Thomas Gainsborough, *Mary and Margaret Gainsborough*, ca. 1775. Oil on canvas, 91½ × 59¼ in. (232.4 × 150.5 cm). Private collection

Fig. 8
Sisters (Susan and Toni) (cat. 12)

Hendricks later recalled the impact of encountering Moroni's portrait of Pietro Secco Suardo (fig. 3) at the Uffizi Gallery in Florence.[19] The portrayal of the black-clad subject with minimal rendering of volume presented Hendricks with a novel solution for creating form, verging on the cusp of figuration and abstraction.[20] Back in his studio, he applied Moroni's method to *Miss T* (cat. 2) and *J.S.B. III* (fig. 4), both of which he described as "a direct byproduct of that influence."[21] Rendering *Miss T*'s bell-bottomed figure as a near silhouette, Hendricks enhances the illusion of volume with the subtle curve of a belt worn low at her hips. That in 1966 Hendricks homed in on a relatively obscure portrait by Moroni—even today not widely known to general audiences—at a museum boasting some of the most famous paintings in the world attests to his independent visual acuity, his ability to seek out individual style.[22]

Hendricks's admiration for Grand Manner portraits by Anthony Van Dyck and Thomas Gainsborough finds expression in his swaggering depictions (figs. 5–8). The impact of Van Dyck can be seen in Hendricks's invention of the long red coat in *Sir Charles, Alias Willie Harris* (fig. 9), and while he credited his triple-figure compositions (e.g., cat. nos. 4, 6, 8) to the mythological motif of the Three Graces, they recall historical precedents such as Philippe de Champaigne's *Triple Portrait of Cardinal de Richelieu* (fig. 10), which Hendricks may have seen at London's National Gallery (itself inspired by Van Dyck's triple portrait of Charles I in the Royal Collection, Windsor).[23] One of the most famous works in the Uffizi, Sandro Botticelli's fifteenth-century depiction of the Three Graces in *Primavera*, inspired artists in the Renaissance and beyond—including Peter Paul Rubens in the seventeenth century (fig. 11). Hendricks would have seen Rubens's famous trio at the Prado Museum, in Madrid.

Hendricks's studies of figures turning in space in his triple portraits also evoke the Renaissance *paragone*: the debate over whether painting or sculpture was the superior form of art. Renaissance painters competed with sculptors by showing the illusion of three dimensions in two-dimensional paintings, some-times using painted reflections to show multiple views of a single figure, or rotating figures in a composition to show them from different sides. Hendricks's triple portraits indulge in the capacity of painting to portray a figure in the round, from more than one perspective, and were motivated in part by his feeling that, for some of his models, "one pose was not enough."[24]

In *Steve*, Hendricks included a reflection of arched windows (those of his State Street studio in New London, Connecticut) and a miniature self-portrait in the sunglasses (page 136 and cat. 10). The reflections do not appear in photographs of the model, who also sported in them a different style of glasses. The device recalls iconic historical paintings that center on miniscule reflections and self-portraits, such as Jan van Eyck's Arnolfini portrait (fig. 12), with its convex mirror reflecting the room and the painter in blue. Centuries later, Diego Velázquez included a more prominent

Fig. 9
Barkley L. Hendricks, *Sir Charles, Alias Willie Harris*, 1972. Oil on canvas, 84⅛ × 72 in. (213.6 × 182.9 cm). National Gallery of Art, Washington; William C. Whitney Foundation

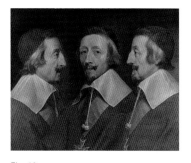

Fig. 10
Philippe de Champaigne and studio, *Triple Portrait of Cardinal de Richelieu*, ca. 1642. Oil on canvas, 23⅛ × 28¹¹⁄₁₆ in. (58.7 × 72.8 cm). National Gallery, London; Presented by Sir Augustus Wollaston Franks, 1869

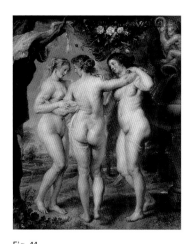

Fig. 11
Peter Paul Rubens, *The Three Graces*, 1630–35. Oil on panel, 86¹³⁄₁₆ × 71⅝ in. (220.5 × 182 cm). Museo Nacional del Prado, Madrid

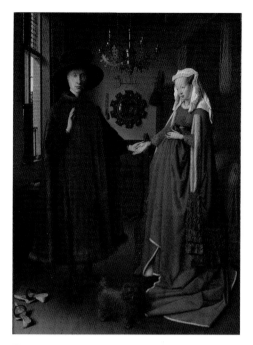

Fig. 12
Jan van Eyck, *Giovanni(?) Arnolfini and His Wife*, 1434. Oil on panel, 32⅜ × 23⅝ in. (82.2 × 60 cm). National Gallery, London; Bought, 1842

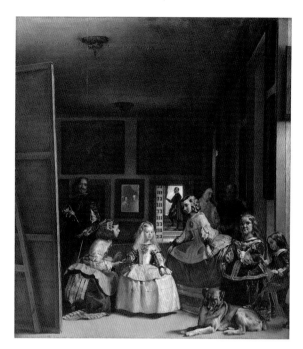

Fig. 13
Diego Rodríguez de Silva y Velázquez, *Las Meninas*, 1656. Oil on canvas, 126³⁄₁₆ × 110¹³⁄₁₆ in. (320.5 × 281.5 cm). Museo Nacional del Prado, Madrid

Fig. 14
Parmigianino, *Self-Portrait in a Convex Mirror*, ca. 1523–24. Oil on panel, 9⅝ × 12¹³⁄₁₆ in. (24.4 × 32.5 cm). Gemäldegalerie, Kunsthistorisches Museum, Vienna

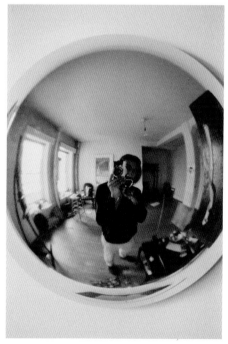

Fig. 15
Barkley L. Hendricks, *Self-Portrait with Hubcap*, 1967. Chromogenic print, 28¼ × 19 in. (71.8 × 48.3 cm). Princeton University Art Museum; Museum purchase, Hugh Leander Adams, Mary Trumbull Adams, and Hugh Trumbull Adams Princeton Art Fund

reflection and self-portrait in *Las Meninas* (fig. 13).[25] Though Hendricks probably encountered these works (he named both Van Eyck and Velázquez as inspirations) and possibly others that use similar devices—like Parmigianino's *Self-Portrait in a Convex Mirror* (fig. 14), which has been compared with Hendricks's photograph of himself reflected in a hubcap (fig. 15)[26]—mirrors and reflections have long been tools in artists' practice, especially in self-portraiture. Spread across time and place, these corollaries bring to the fore a broader artistic interest in reflections, in painting one's own presence into one's art, and in the myriad ways each artist arrives at a solution.

As one looks at Hendricks's work in the broad history of portraiture in Western culture, more and more points of comparison can be seen between his artistic approaches and experiences and those of earlier artists. His editing of figures, for example—such as omitting the birthmarks (seen in photographs) on the arm and neck of the model for *October's Gone . . . Goodnight* (cat. 4)—brings to mind Renaissance artists such as Bronzino, who in his portrait of Duke Cosimo de' Medici left out the prominent mole on his cheek (known from a sculpture of the duke by Benvenuto Cellini). Hendricks's occasional initiating of impromptu photo shoots of individuals he spotted walking on the street (see cat. 9) emphasizes the advantage of photography as a "mechanical sketchbook" (as he often referred to his camera) that was not available to eighteenth-century artists such as Jean-Baptiste Greuze, who would become so captivated by people he saw on the streets of Paris that he would follow them around, begging them to come to his studio so he could draw them there.

Hendricks's experience with censorship is another point of connection with many artists over the centuries, including Michelangelo. In 1984, for example, concerns about the response of the Christian community over gold crosses and high-heeled shoes in Hendricks's art resulted in the exclusion of certain works from public exhibition; his *Family Jules: NNN* (see fig. 35), which depicts a nude Black male subject, has been omitted from exhibitions on similar grounds.[27] Also in the name of Christian modesty, shortly after Michelangelo's death, a younger painter was hired to paint over all of the exposed genitals in Michelangelo's monumental *Last Judgment* in the Sistine Chapel. The overpaint was only partially removed in the late twentieth century.

Figure and Ground

Hendricks's portraits touch upon a long history of artistic exploration of the tensions between figure and ground. Their visual force derives in part from his use of different materials for the subject and the background: "For me," he said, "one medium does not fit all illusions and concepts."[28] With figures painted in oils and varnished, and backgrounds painted in matte acrylic (or Magna),

Fig. 16
Barkley L. Hendricks, *Miss Brown to You*,
1970. Oil and acrylic on canvas, 48 × 48 in.
(121.9 × 121.9 cm).

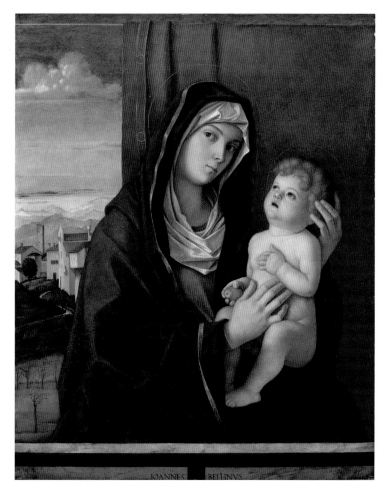

Fig. 17
Giovanni Bellini, *Madonna and Child*, late
1480s. Oil on panel, 35 × 28 in. (88.9 × 71.1
cm). Metropolitan Museum of Art, New
York; Rogers Fund, 1908

AIMEE NG

the resulting contrast can only be fully appreciated when viewing his portraits in person. The varnished oil-painted figure glistens in light, as if on a separate plane from the matte acrylic. The integration of different media recalls a story about Leonardo da Vinci—one of Hendricks's most admired Renaissance artists—who, as an assistant in Andrea del Verrocchio's studio, reportedly shocked his master with his skill in painting an angel in Verrocchio's *Baptism of Christ* (Uffizi, Florence). The young Leonardo had painted the angel in the then-innovative medium of oil, while much of the rest of the composition had been executed in tempera.[29] As with Hendricks's work, the difference in media amplified the distinction between the figure and its surroundings.

Whether he studied his models in his studio or from photographs taken on the street, Hendricks often set his figures against an expanse of matte color, an almost otherworldly space as meditative as the shimmering gold grounds that signaled divinity (fig. 16). Notable exceptions include *Family Jules* (see fig. 35), the interior domestic setting of which was in part inspired by sixteenth-century Moroccan tilework.[30] Recalling the Christian tradition of portraying the enthroned Virgin Mary against a Cloth of Honor (fig. 17) and the artistic playfulness around the illusions of backdrops, Hendricks's backgrounds, especially those featuring intense color, evoke the brilliant backgrounds in portraits such as one of Hendricks's favorite works in The Frick Collection, Bronzino's *Lodovico Capponi* (figs. 18, 19). At the same time, through the "unlikely" genre of figurative representation, they resonate with the modernist flatness of Piet Mondrian, of minimalism and pop art, of color field painting.[31]

With as little as the tip of a toe sometimes cut off by the painting's edge, cropping is a crucial element of Hendricks's compositions. Exacting cuts activate his compositions, emphasizing and energizing the boundaries of the field of view, and they assert the artist's ability to capture his figures just so, staged within the frame. His photography practice undoubtedly refined his mastery in framing, and his study of historical European art may also have been instructive. Moroni, for example, cropped his portraits tightly—accentuating the proximity of the subject to the picture plane, thus to the viewer—and some later owners added strips of canvas to enlarge Moroni's paintings, to create more space around the sitters and thus more distance from the viewer. Throughout early modern Europe, artists experimented with frames and boundaries, from sculptors making loaded decisions about where to "cut" a figure's body for a bust portrait—at the neck, shoulders, or below—to painters playing with the illusion of fictive frames and other devices. Hendricks shared with these artists a fascination with figures occupying their bounded spaces.

In his seminal exploration of Hendricks's portraiture, Richard J. Powell explores Black Arts Movement co-founder Amiri Baraka's conception of "terribleness" as it relates to Hendricks's sitters: the awesomeness and audacity of their self-presentation.[32] Centuries and worlds apart, Baraka's "terribleness" recalls the *terribilità* of

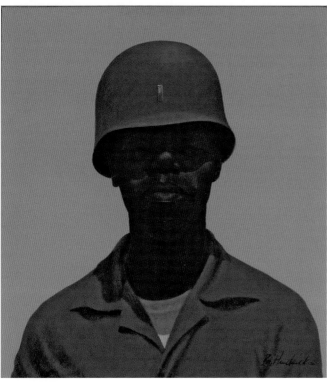

Michelangelo and his art in sixteenth-century Italy, described by his contemporaries as a force so great that its impact induced both pleasure and fear, like the awesomeness of God. In the Renaissance, Michelangelo's *terribilità* was not limited to the works the artist created but extended to the artist himself. So too might Hendricks himself—as captured in his many self-portraits—be seen to embody the awesomeness with which he charged his portraits.

Flesh

This volume and the exhibition it accompanies bring together a group of Hendricks's "limited palette" paintings, in which he paints a figure and its background in monochrome, the two largely distinguished by the glossy finish of varnished oil against matte acrylic. In the white-on-white limited-palette works in particular, the figures' brown skin tones and the dark-hued details of clothing and accessories become abstract shapes from afar. Up close, the variation within the dark tones and the color white become evident.[33] Displayed near this group in the exhibition at Frick Madison is a room of portraits by James McNeill Whistler. Separated by about a century, the two artists explore similar tensions among color, shape, and surface. Zoé Whitley has related Hendricks's white-on-white, limited-palette works to Whistler's suite of portraits called *Symphony in White* (fig. 20).[34] Whistler approached his paintings like musical compositions, combining formal elements of color and shape and giving them musical titles such as *Harmony in Pink and Grey: Portrait of Lady Meux* and *Arrangement in Black and Gold: Comte Robert de Montesquiou-Fezensac* (fig. 21). Titles like *Symphony in Flesh Colour and Pink: Portrait of Mrs. Frances Leyland* (another portrait at the Frick) underline the way in which, in Whistler's time, "flesh color" was synonymous with light-colored skin, implying a stable, single color, as if one could buy a tube of paint called "flesh" (which one can, today).[35]

Whistler was criticized for many things in his volatile career but not for failing to vary the colors of skin. Meanwhile, one critic wrote of Hendricks: "Painting black skin—the way it takes light, variations of color and tone—seems not to inspire him either, for he glazes most subjects the same all-purpose brown."[36] Hendricks's response emphasizes the inherent semantic inaccuracy of "Black" skin (and by extension, "white"):

> Damn, even Stevie Wonder and Ray Charles can see a difference in the variety of skin handling I was involved with! The attempt on my part is always to address the beauty and variety of complexion colors that we call Black.[37]

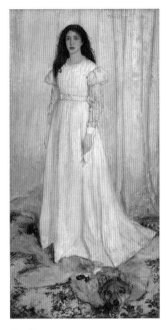

Fig. 20
James McNeill Whistler, *Symphony in White, No. 1: The White Girl*, 1861–63, 1872. Oil on canvas, 83⅞ × 42½ in. (213 × 107.9 cm). National Gallery of Art, Washington; Harris Whittemore Collection

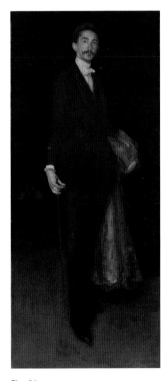

Fig. 21
James McNeill Whistler, *Arrangement in Black and Gold: Comte Robert de Montesquiou-Fezensac*, 1891–92. Oil on canvas, 82⅛ × 36⅛ in. (208.6 × 91.8 cm). The Frick Collection, New York

Hendricks's exploration of the eloquence and diversity of Black skin is particularly evident in *Lagos Ladies*, in which the skin tones of four women are as varied as their footwear, which he studied in an independent photograph (cat. 14, fig. 96). As he applied various background colors—from black and white to jewel tones and more subtle hues and metal leaf—the effect of his sitters' skin colors, the hues of Black skin, changes.

As Hendricks pointed out, Black figures are not absent in historical European art. Often appearing as servants or slaves or in Christian art as the king Balthazar—one of the three Wise Men, or Magi, who visited the newborn Christ Child (fig. 22)—and a small number of Black saints, they are rarely the subject of individualized, personalized portraits, even if studies of Black models for such characters can be portrait-like, such as Rembrandt's famous study *Two African Men* (Mauritshuis, The Hague). In the limited number of historical European portraits of Black sitters known today, the sitters' skin is not simply the representation of "Black skin"—as in a generalized figure of African descent—but the particular skin of a particular person. When Hendricks set out on his first European trip in the summer of 1966, he would have seen few such portraits, perhaps none. He need not have seen any of them to accomplish and invent what he did. Velázquez's *Juan de Pareja* (fig. 24), arguably the best-known historical European portrait of a Black subject in the United States, entered the collection of the Metropolitan Museum of Art in New York in 1970.[38] Many historical portraits of Black sitters were not acquired by European and American museums until later in the century; for example, the depiction of an unidentified man in the Rijksmuseum, probably the earliest-known such portrait (fig. 23), did not enter the museum until 2005. Though Hendricks may not have seen Anne-Louis Girodet's portrait of Jean-Baptiste Belley (fig. 25)—a freed slave who came to hold a position in Napoleon's government—the portrait might be imagined as a distant artistic ancestor to some of Hendricks's figures. (When first exhibited in Paris in 1797, however, the portrait of Belley was presented as *Le portrait d'un Nègre* (Portrait of a Negro), was later misidentified as depicting Toussaint Louverture, and—though at the palace of Versailles since 1852—arguably did not enter general art-historical discussions until 1972.)[39]

Depictions of Black men by the leading eighteenth-century British painters and rivals Thomas Gainsborough and Joshua Reynolds exemplify historical experiments with brown skin colors as an artistic challenge—and not solely as a representational one. Gainsborough's portrait of Ignatius Sancho (fig. 26), who was born on a slave ship and ultimately earned renown in Britain as a literary figure, was probably painted at the behest of Sancho's employers, the Duke and Duchess of Montagu, as a gift for him; it remained in Sancho's family until the early nineteenth century.[40] An inscription on the back of the frame states that Gainsborough painted it very quickly—in one hour and forty minutes—on November 29, 1768 (whether or not it is reliable is uncertain). Gainsborough, who does not appear to have painted any other

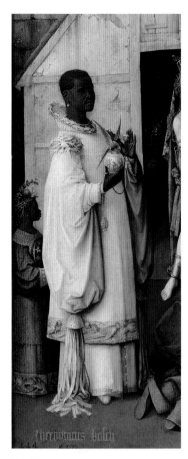

Fig. 22
Hieronymus Bosch, *Triptych of the Adoration of the Magi* (detail), ca. 1494. Oil on panel, 58 × 66⅜ in. (147.4 × 168.6 cm). Museo Nacional del Prado, Madrid

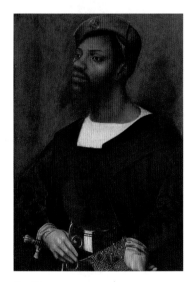

Fig. 23
Jan Jansz Mostaert, *Portrait of an African Man*, ca. 1525–ca. 1530. Oil on panel, 12⅛ × 8⅜ in. (30.8 cm × 21.2 cm). Rijksmuseum, Amsterdam

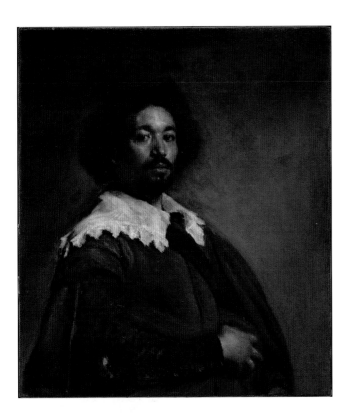

Fig. 24
Diego Rodríguez de Silva y Velázquez,
Juan de Pareja (ca. 1608–1670), 1650. Oil
on canvas, 32 × 27½ in. (81.3 × 69.9 cm).
Metropolitan Museum of Art, New York;
Purchase, Fletcher and Rogers Funds, and
Bequest of Miss Adelaide Milton de Groot
(1876–1967), by exchange, supplemented
by gifts from friends of the Museum, 1971

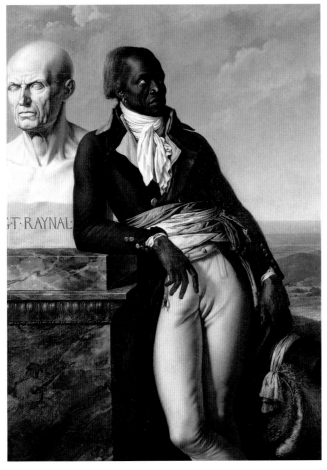

Fig. 25
Anne-Louis Girodet de Roucy-Trioson,
*Jean-Baptiste Belley, député de Saint-
Domingue*, 1797. Oil on canvas, 62¹³/₁₆ ×
44⁷/₁₆ in. (159.5 × 112.8 cm). Château
de Versailles

person of color, when faced with the artistic challenge of painting Sancho, seems to have simply applied his formulaic approach to portraiture of white subjects, using a canvas prepared with a dark brown ground, ideal for setting off light skin. He would have had a number of such prepared canvases ready in his studio for his otherwise exclusively light-skinned clientele. The portrait's present condition has suffered from past overcleaning, especially in the face, which probably was originally modeled with more highlights. It may have once had the effect of a contemporaneous portrait of a Black man in the Royal Albert Memorial Museum in Exeter (fig. 27), in which the sitter's facial features and skin are depicted with a wide range of values and emphatic highlights, set against a conventional brown background.[41]

Reynolds's unfinished portrait of an unidentified Black man takes a different approach (fig. 28). That it was intended as a portrait of the sitter—as opposed to a study of the model for other purposes—cannot be confirmed, and his identification as Francis Barber, servant to the writer Samuel Johnson, has not been accepted unanimously; he may have been Reynolds's own servant.[42] Nevertheless, the dignity and aloof expression of the model give the sense of a portrait. Reynolds set the figure's head against a light ground, inverting the convention seen in *Ignatius Sancho*. The flesh of Reynolds's sitter is composed of various colors—hardly a single brown hue. The fact that there are a number of copies of the painting suggests that Reynolds—longtime president of the Royal Academy of Arts in London—used this portrait to encourage his pupils to learn how to paint brown skin.[43] His experience with painting darker flesh tones, and their effective placement against light backgrounds, was gained by painting numerous portraits of white sitters accompanied by servants and enslaved people with darker complexions. He also recorded in his appointment book multiple sittings with someone he refers to simply as "negro," probably the Black servant who appears in his portrait of Lady Keppel (Woburn Abbey).[44] The complexity of his taking the time to study a particular Black person for portrait sittings but referring to her simply as an ethnicity complicates efforts to see Reynolds as a force for humanizing subjects of color. Still, his artistic approaches to painting these figures attests to his understanding of darker flesh tones as a rich painterly opportunity, which he shared with his pupils. They carry a kernel of Hendricks's conviction to address "the beauty and variety of complexion colors that we call Black."

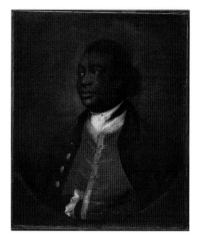

Fig. 26
Thomas Gainsborough, *Ignatius Sancho*, 1768. Oil on canvas, 29 × 24½ in. (73.7 × 62.2 cm). National Gallery of Canada, Ottawa; Purchased 1907

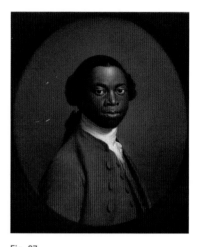

Fig. 27
Attributed to Allan Ramsay, *Portrait of an African*, ca. 1758. Oil on canvas, 24⁵⁄₁₆ × 20¼ in. (61.8 × 51.5 cm). Royal Albert Memorial Museum, Exeter

Hendricks's engagement with historical European art raises the question of what he thought his viewers might know and see: whether or not he expected them to recognize the roots of *Miss T* in Italian Renaissance artists like Moroni, of *Lawdy Mama* in

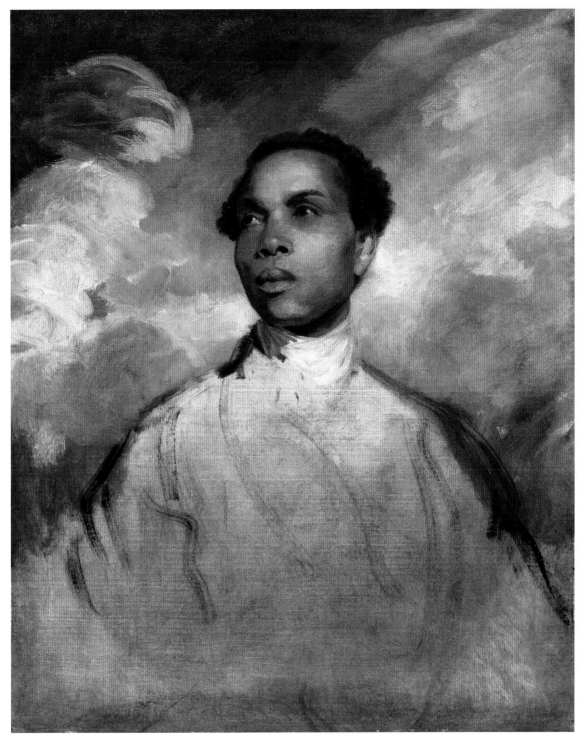

Fig. 28
Joshua Reynolds, *Portrait of a Man,*
probably Francis Barber, ca. 1770. Oil on
canvas, 31 × 25⅛ in. (78.7 × 63.8 cm).
The Menil Collection, Houston

religious icons. His experiments with lessons of the Old Masters were not limited to figurative painting: a number of basketball-themed paintings, produced alongside the 1970s portraits, use similar combinations of oil paints on acrylic backgrounds (fig. 29), as well as evoke Dutch still-life paintings in the naturalistic rendering of objects, as seen, for example, in *Father, Son, and . . .* (fig. 30), which refers to Christian altarpieces in its triptych format and title. His approach to his viewers may have been like his perspective on European artistic forebears such as Rembrandt, and on his subjects, sometimes encountered as perfect strangers on the street: they could come as they were. In discussing the gold grounds in works such as *Lawdy Mama*, for example, Hendricks acknowledged their historical inspiration but at the same time understood them simply as "shiny things."[45] He capitalized on the appeal of things that sparkle and shine, regardless of prior knowledge or the privilege of trips to Europe. That he was invested in connecting with his viewers, human to human, underlies his preferences for how his paintings should be installed: he requested that they be hung relatively low—unlike in traditional European galleries, in which the height of portraits often puts the viewer at the subject's feet—so that they might meet their beholders eye to eye.[46]

Hendricks was a voracious museum-goer with a keen eye for historical techniques, styles, and solutions, and he transformed his borrowings and emulations into something utterly new. As such, his debt to Old Master painting remains a rich topic that could be explored in many more pages than this essay. But the debt also goes the other way. Hendricks showed a way to productively engage with the complex legacies of historical European art while honoring people largely excluded from its visual record. His project has encouraged generations of audiences and artists to see Old Master paintings as they may never have otherwise, bringing them alive for viewers who might see historical European art in very different ways (achievements; atrocities)—bridging, through his art, what even today can seem like insurmountable distances between people.

Fig. 29
Barkley L. Hendricks, *Granada*, 1967.
Oil and acrylic on canvas, 46¼ × 48 in.
(117.5 × 121.9 cm). Private collection

Fig. 30
Barkley L. Hendricks, *Father, Son, and . . .*,
1969. Oil and acrylic on canvas, each panel
54 × 109¼ in. (137.2 × 277.5 cm); overall
triptych 54 × 109¼ in. (137.2 × 277.5 cm).
Art Bridges

1 "Barkley L. Hendricks on Rembrandt," courtesy the Nasher Museum of Art at Duke University, Durham, N.C. With thanks to Wendy Hower, who filmed the video and interviewed the artist. In the video, Hendricks discusses The Frick Collection's 2011 show *Rembrandt and His School: Masterworks from The Frick and Lugt Collections*.

2 Hendricks in conversation with Trevor Schoonmaker, May 13, 2007; Schoonmaker 2008–10, 19.

3 For a recent account of some of these debates, see the article headlined "Is it time the art world ditched the term 'old master'?"; Thorpe 2020.

4 Hendricks was the first Black student at the Pennsylvania Academy of the Fine Arts to win consecutive travel scholarships. After receiving the Cresson scholarship for travel in Europe in 1966, he won the J. Henry Scheidt traveling scholarship in 1967. See Durham and other cities 2008–10, 124.

5 In 1977, he attended the Second World Black and African Festival of Arts and Culture (FESTAC) in Lagos, Nigeria; and in 1978, he traveled to Nigeria, Ghana, Benin, and Togo; Durham and other cities 2008–10, 124.

6 Raynor 1982.

7 On Hendricks and audacity, see Richard J. Powell in Whitely forthcoming.

8 Raynor 1982: "But his subjects notwithstanding, Mr. Hendricks seems not to be making a political statement, nor does he show much interest in the individuality of his characters other than as expressed through their clothes." Regarding other critics' perspectives on his art, Raynor noted: "It is not for nothing that some critics have termed him slick: a touch like the gray balloon held by a chic black woman in a white pants suit and paired off with the pink bubble that emerges from her mouth is worthy of a clever fashion photographer."

9 On tensions in his portraiture between artistic effects and politics, the artist remarked: "People have always connected me with a political situation. I'm more about illusion. When you look at one of my paintings, you'll see that there are glasses, or a shirt that looks like wool. I want that to be something that resonates with you first, rather than trying to be connected with the unfortunate situation people of color face. There's a script that's been written, whether we like it or not. We're all a part of it. What needs to happen is for artists to get up and get out of that headlock scenario—out of a script that's been written that you had no control over"; Pedro 2016.

10 Hendricks in conversation with Anna Arabindan-Kesson, August 25, 2016; quoted in Arabindan-Kesson 2017a. See also Whitley 2017–20, 198.

11 Hendricks in conversation with Anna Arabindan-Kesson, August 25, 2016; quoted in Arabindan-Kesson 2017a.

12 "Some might call it romantic; others might call it dedicated, or even brave. But whatever the case, Hendricks has demonstrated over and over again integrity in his vision that is independent of popular movements and styles in the contemporary art world"; Schoonmaker 2008–10, 36.

13 Hendricks (in Durham and other cities 2008–10, 98) referred to his former girlfriend Adrienne Hawkins as the "body double, so to speak, for the lone nude in *What's Going On*."

14 The Cresson scholarship at the Pennsylvania Academy of the Fine Arts was awarded only for travel in Europe. This was the artist's first trip outside of the United States; Hendricks 2009.

15 Durham and other cities 2008–10, 105. The artist recounted visiting the National Gallery in London, the Uffizi Gallery in Florence, the Vatican museums, the Rijksmuseum in Amsterdam, the Prado Museum in Madrid, and the National Gallery in Athens, noting his interest in many artists, among them, Caravaggio, Gainsborough, Moroni, Rembrandt, Titian, Turner, Van Dyck, Van Eyck, Velázquez, and Vermeer; Hendricks 2009.

16 From Hendricks's artist statement, "Rome Rendezvous: Rendezvous with Myself," in New London 2001. See Arabindan-Kesson 2017b, note 36, on identifying the particular Van Dyck painting Hendricks may have been referring to, possibly Philippe de Champaigne's *Cardinal Richelieu*.

17 He noted his interest in Byzantine icons and early Italian Renaissance paintings; Hendricks 2009. Regarding the gold leafing in *Lawdy Mama*: "Being reacquainted with *Lawdy Mama*, it kind of makes me think of the ordeal I went through in putting the gold leaf down. It worked the hell out of me"; Hendricks 2008–10, 76. His first test painting using gold leaf was the 1968 self-portrait *Butch* (private collection).

18 According to Richard J. Powell (2008–10, 42), based on interviews with Hendricks, the title was taken from a verbal aside in a recording by Nina Simone; it also recalls Nina Simone's "Blues for Mama" (1967), which begins "Hey lordy mama / I heard you wasn't feeling good / They're spreadin' dirty rumors / All around the neighborhood."

19 Durham and other cities 2008–10, 105.

20 The flatness of the black paints in paintings by Moroni and his contemporaries has been exaggerated over centuries through the thinning and sinking of paints (and sometimes from overcleaning), but Moroni is known to have been highly efficient in his use of materials and painted thinly.

21 Durham and other cities 2008–10, 105.

22 The Frick mounted an exhibition centered on the portraits of Moroni in 2019, the first major exhibition dedicated to the artist in the United States.

23 "While some might draw links between Hendricks's *Sir Charles, Alias Willie Harris* and Anthony van Dyck's well-

known *Charles I in Three Positions* (1635–36), Hendricks recounts a different lineage for his painting and its title. Sir Charles's red coat was an innovation on Hendricks's part, a response to middle-class African American prohibitions against wearing the color red (regarded as too conspicuous and uncouth a color and thus a mark of the lower classes). Hendricks further explained that Sir Charles, a procurer of illegal drugs for some Yale University students, would frequently disappear with their money, like the infamous, physically absent character "Willy Harris" in Lorraine Hansberry's award-winning play *A Raisin in the Sun* (1959); Powell 2008, 145, drawn from an interview with Barkley Hendricks.

24 Durham and other cities 2008–10, 105.

25 Hendricks referred to both Jan van Eyck and Velázquez when naming artists he encountered and liked in his early travels in Europe; see note 15 above.

26 Ankori (in Waltham 2022, 36–37) also draws attention to the examples of Van Eyck and Velázquez.

27 Durham and other cities 2008–10, 117 and 120: "I was told I would not be able to show any nudes [at his first solo exhibition in the South at the Greenville County Museum of Art, in South Carolina]. I later discovered they had white nudes in their collection. My black nudes were just too 'black,' so I've been told."

28 "The visual illusion that I wanted to create was as though the person was coming off the canvas, and the flatness to create that illusion would take forever to dry if I used oil. At the time, I was introduced to using acrylics. I could roll my colors on in a day with acrylic and be finished and that way, I could see where I was going with the other parts of the canvas"; Hendricks 2008–10, 67.

29 On technical examination of the painting with respect to this story, first recounted by Vasari, see Dunkerton 2011.

30 See Arabindan-Kesson 2017b.

31 For Hendricks's engagement with minimalism, see Schoonmaker 2008–10, 26: "Through their monochromatic backgrounds, flattened space, and simplified palette, this series demonstrates Hendricks's limited but willful engagement with minimalism." For the artist's engagement with formalism, see Powell 2008–10, 44: "Figure/ground distinctions—created by painting figures with oils and glazes and, in contrast, painting backgrounds with matte acrylics—underscored the formalist thinking behind these depictions, and Hendricks's adherence in painted portraiture to a sequestered yet sympathetic presentation."

32 Powell 2008, 127–28.

33 During a visit to the Harvard Art Museums on March 21, 2017, Hendricks described his initial intention for the white-on-white paintings to have a subtle contrast in hue and value between the figure and ground; he also stated that the yellowing of the varnish on the figure over time had diminished the contrast—an unexpected effect that he liked. See Harvard Art Museums, Conservation files. My thanks to Kate Smith, Conservator of Paintings, for sharing her report of the visit with me.

34 Z. Whitley in London and other cities 2017–20, 198. On *Symphony in White*, see London and Washington 2022.

35 Winsor & Newton sell a tube of paint called "Flesh Tint," which is a peachy color.

36 Raynor 1982.

37 Whitley 2017–20, 193.

38 Knight (2009) posited this event as instrumental in the evolution of Hendricks's "swagger portraits": "Interestingly, Hendricks' work in this vein hit its stride shortly after New York's Metropolitan Museum of Art acquired—with great fanfare and for a then-record price—Diego Velázquez's astounding 1650 swagger portrait of Juan de Pareja, a Sevillian of Moorish descent. Perhaps it was just a coincidence, but the fact that the greatest Baroque portrait in America now depicted a black man was an irony unlikely to have been lost on an artist of Hendricks' distinctive gifts."

39 Bellenger 2005–7, no. 66.

40 Belsey 2019, no. 796.

41 There is no consensus regarding the authorship of the portrait, which is called *Portrait of an African* by its owning institution. Madin (2006, 34–39) attributes the portrait to Allan Ramsay and identifies the sitter (unconvincingly) as Ignatius Sancho.

42 Mannings 2000, no. 2003. The painting entered the Menil Foundation collection in 1983.

43 It has not been possible to confirm whether or not a version after Reynolds's portrait in the collection of the Tate Gallery (inv. no. N05843) was on view in London in the summer of 1966, when Hendricks visited London. My thanks to Martin Myrone, Amy Concannon, and Chris Bastock for their help with this inquiry.

44 Mannings 2000, no. 1052.

45 Hendricks 2009; Durham and other cities 2008–10, 67: "There's that association with icons, and I just like shiny stuff."

46 Hendricks 2009: keeping portraits "close to human scale, you have a better chance of having the human that's looking at it interact with that." See also Hendricks 2008–10, 70: "There's an interaction that I want to have with the spectator, and using the human scale I think makes that point a little bit better for me." During his visit to the Harvard Art Museums on March 21, 2017, Hendricks remarked that he preferred a lower hanging height for his paintings, as a higher height, typical at museums, "disrupts the illusion;" Harvard Art Museums, Conservation files.

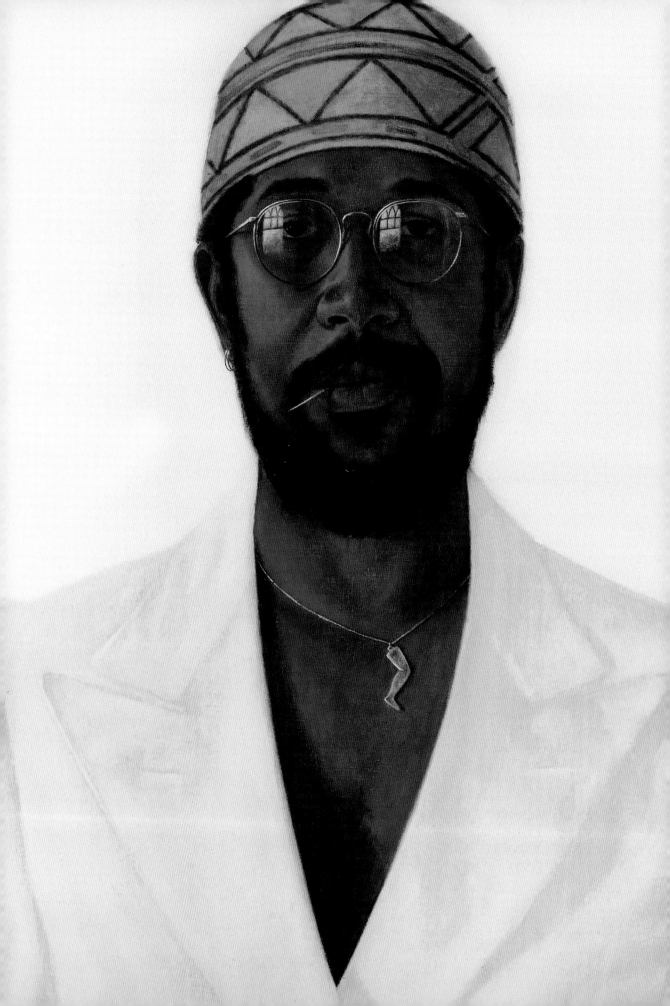

Barkley L. Hendricks: To Be Real

ANTWAUN SARGENT

And he was transfigured before them,
and his face shone like the sun,
and his clothes became white as light.

—MATTHEW 17:2

I.

The first portrait Barkley Leonnard Hendricks painted was of a
nun. Arms crossed, eyes peering out in confident suspicion, she
is in three-quarter profile in her voluminous black habit against a
flat, dark ground. She would be hard to see if not for the luminous
white coif that frames her face and covers her shoulders. What
further defines her corporeal presence is a large, glimmering, gold
rosary styled around her waist, like the edge of a conspicuous
corset. The rosary is slyly revealing, showing us that this faith work-
er has the hips of a goddess-like figure. This accessory is a symbol
of identity, burden, and creed, recalling the large millstone Jesus
instructed his followers to fasten around the neck of any non-
believer.[1] But she is not one of them—she believes. In her stance
and appearance, the nun conveys an attitude of worship that exists
beyond traditional Catholicism: Hendricks's portrait is of a sister
and a *sista*.

The painting, *My Black Nun* (fig. 31), was drawn from Hendricks's imagination and memory when he was coming of age in Philadelphia. He would later say that he made the portrait from a place of absence and correction. "As a kid, I used to pass a Catholic school and later on, I started wondering . . . I never saw any Black nuns. So, I decided to paint my own."[2] The roughly 12-by-7-inch, black-on-black portrait is rendered in oil on a small piece of Masonite board. Although Hendricks painted it when he was just nineteen years old, it would, as curator Trevor Schoonmaker has argued, establish the central social and formal concerns that preoccupied the artist for the rest of his life. The tiny picture reflects Hendricks's trademark practice of subverting ideas about who could be the subjects of a canvas and who could be icons of power, belief, and beauty in Western painting. It also provides an early example of Hendricks's lifelong experimentation with scale, texture, dimension, perspective, and wondrous fields of color, qualities that Hendricks believed gave "the illusion of form without a lot of detail."[3]

In the late 1960s, Hendricks took two foundational trips, one to North Africa and the other to Europe, where he saw the portraiture of Old Masters such as Rembrandt, Van Dyck, and Caravaggio. The sublime beauty of the portraits, together with the artists' inventive techniques and the extraordinary displays of power, fashion, and wealth the paintings represented, made a lasting impression on Hendricks, as did his studies at the Pennsylvania Academy of the Fine Arts and later Yale University, where he made photography a central part of his practice. He was struck by how little of himself, or the old neighborhood, he saw in the canvases at the campus museums in New Haven and at the Louvre and the Uffizi. As Aimee Ng discusses in her essay in this publication, a breakthrough came with his trip to the National Gallery, in London, when he saw a portrait by Van Dyck.

In the postwar period, during Hendricks's formative years, figuration had taken a backseat to conceptualism and abstraction in the white art world. In 1965, after the assassination of Malcolm X and against the backdrop of the civil rights era, the Black Arts Movement (BAM), an "aesthetic and spiritual sister"[4] of the Black Power movement, was born. The aim of this loose group of Black artists, musicians, and writers—led by poets Amiri Baraka (formerly LeRoi Jones) and Larry Neal—was to develop a "Black Aesthetic," as explained in Neal's essay and manifesto "The Black Arts Movement" (1968). He began by saying that BAM was "radically opposed to any concept of the artist that alienates him from his community." To Neal, the "task" of Black artists was inherently political: he wanted them to advocate for the "Afro-American's desire for self-determination and nationhood." "Both concepts," he wrote, "are nationalistic. One is concerned with the relationship between art and politics; the other with the art of politics."[5]

In 1969, a few years after the formation of BAM, Hendricks painted *Icon for My Man Superman (Superman Never Saved Any Black People—Bobby Seale)* (fig. 32). In this partially nude self-

Fig. 31
Barkley L. Hendricks, *My Black Nun*, 1964.
Oil on Masonite board, 11¾ × 7¼ in.
(29.9 × 18.4 cm). Private collection

ANTWAUN SARGENT

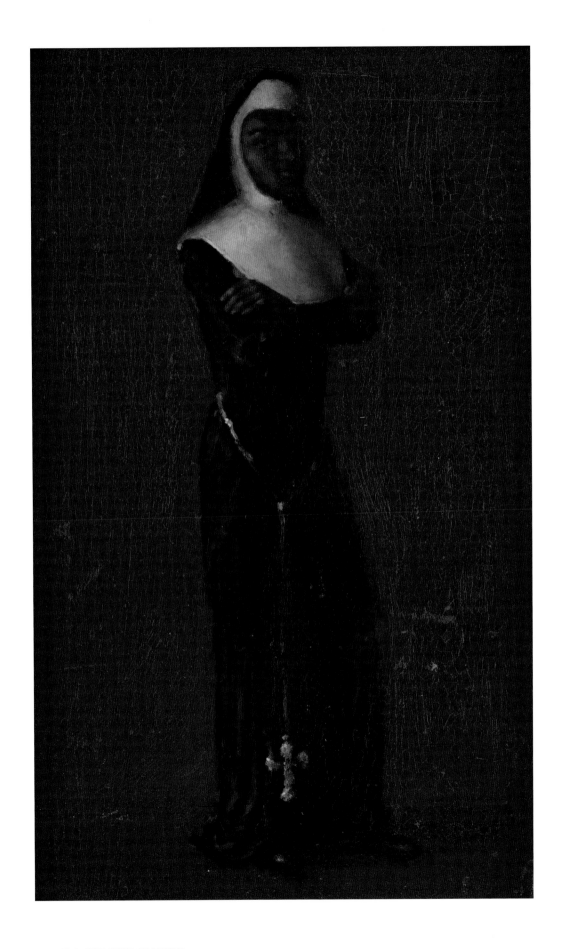

portrait, the artist uses style (his afro, Superman T-shirt, sun-glasses, and posture) to humorously critique the narrow ideas of Black liberation that had come to represent the movement. During this period, Hendricks also set out to paint something the Black and white art worlds had not seen: ordinary people at scale. The life-size portraits he produced were of friends, students, lovers, musicians, classmates, the local weed man, himself, his wife, fashionable family members, and complete strangers. *Blood (Donald Formey)* (cat. 7), for instance, depicts a young Black guy wearing a harlequin-checked twinset while holding a tambourine at his side, set against a red background that recalls the red robes in several Van Dyck portraits. Hendricks's pictures stood out because they were not portraying Black or white people with an agenda. Nonetheless, they participated in the conversations and artistic concerns of the day. Many of his photorealist portraits have the shine or superficiality of pop art, the color play of ab-straction, and the selective palette of minimalism. Moreover, in deploying fashion, his images conferred allure and status on often underrepresented figures, while at the same time drawing connections to contemporary culture.

As Hendricks put it, "I wanted to deal with the beauty, grandeur, style of my folks. Not the misery. We were ahead in many areas of culture like fashion, certainly music."[6] He would often see someone "bopping down the street" and ask, "Can I do a shot?" This democratic way of making portraits—creating an image as a kind of witness—cuts against the tendencies of the period. To Hendricks, anyone who caught his attention was worth memorializing, regardless of their station in life. Images such as *Hasty Tasty* (fig. 33), a portrait of an embracing, white, gay couple he encountered on the street, or *Brilliantly Endowed* (page 147), a nude self-portrait he made in reaction to the critic Hilton Kramer calling him "brilliantly endowed"[7] in a *New York Times* review, were provocative acts of refusal, and humorous.

Hendricks was not painting himself or his people to suggest that they were some kind of problem. His paintings were not meant as alternative portraits of an underclass. A subject who has marginal status is still the subject, the center. He and his subjects are the protagonists of their own lives; the entire narrative of the painting is the fact of the subject's existence, which is to say he painted these people because they existed. That was enough. "I was not fascinated with myself as much as Rembrandt or de-pressed to the extent of Van Gogh," Hendricks wrote about his self-portraits. "However at times, I could not resist myself as a subject."[8]

Hendricks's images create space for multiple perspectives of any given subject. Hendricks makes this point most directly in those works that present a figure from multiple vantage points. *Northern Lights* (cat. 8), for instance, presents three views of a slender, fancifully dressed male. In a wide-brim Persian blue hat that complements a forest-green leather trench coat with a white fur collar, the figure is shown three times: looking straight ahead,

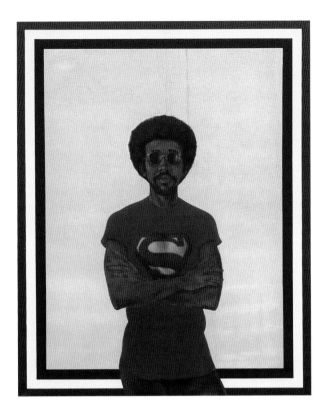

Fig. 32
Barkley L. Hendricks, *Icon for My Man Superman (Superman Never Saved Any Black People—Bobby Seale)*, 1969. Oil, acrylic, and aluminum leaf on canvas, 59½ × 48 in. (151 × 121.9 cm). Private collection

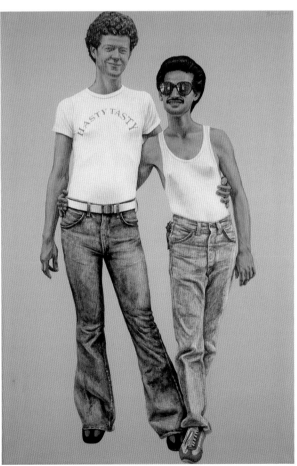

Fig. 33
Barkley L. Hendricks, *Hasty Tasty*, 1977. Oil and acrylic on canvas, 72 × 48 in. (182.9 × 121.9 cm). Museum of Fine Arts, Houston; Gift of Michael Zilkha in honor of Bill Arning and Mark McCray

turned to the left in profile, and in three-quarter-view facing right. From each angle, he can be seen flashing a slick smile that reveals a single gold-capped tooth. The composition—which Hendricks said was directly influenced by depictions of the Three Graces (see fig. 11)—recalls the way a camera might capture a series of stills of a subject, providing a different sense of self, or what Hendricks called "personality,"[9] with each shot. The way Hendricks applied a photographer's approach to perspective invited a new way of looking at "the kind of images that some people were only willing to read and understand as stereotypes," as curator Thelma Golden has noted.[10] A case in point: "Someone once referred to the figure I did in the *Northern Lights* painting as a pimp," Hendricks wrote. "It was his big hat and large fur-collared coat that was behind that assessment. I said, 'I once saw Ronald Reagan in the same large fur-collared coat. Did that make him a pimp?'"[11]

In these paintings, you see class, race, and sexuality as well as a conferring of value on the disempowered. With the bold, expressive style of his figures and the great care he takes in rendering them, Hendricks also challenges us to see something more individual and interior, to look again, to see his people beyond the first thought that might occur to his audience. In some portraits, this challenge reaches confrontation. In *Bid 'Em In / Slave (Angie)* (fig. 34), the subject stands wearing a tight, white tank top with the word *slave* (partially covered by the figure's crossed arms) written across it. Her face is impassive, and sunglasses cover her eyes. Hendricks encountered the woman on the street, wearing the outfit in which he painted her. What does one make of her? How does she use the shirt to label herself? A Hendricks sitter is figured through fashion; but in the artist's pictures, fashion also functions as its own figure. It tells us that an impression of a person is not, in fact, the person.

Hendricks's oeuvre is more than simply the representation of those on the margins, it is a search for self, never settled. His sitters, in all their attitude and satirical flair, are asking, "Do you see me?" In this way, it is a struggle for me to describe his work with the catch-all term that "representation" has become, especially at this moment of overcorrection and hyper-visibility, in which people who exist at the edge are depicted with humanity. Hendricks's figures possess a unique sense of self, as shown through their style, an expression of choice. They do not allow themselves to be understood as idealized stand-ins for a larger group. Their self-fashioning is precisely that: the fashioning of self.

Hendricks's canvases are about the constraints and freedoms of the world his figures live in. That world is seen in their self-fashioning; they are both wearing their realities on their sleeves and dreaming, in style, of other ways of being. His oeuvre runs counter to the paintings of prominent Black figures that were typical of the era in which Hendricks was most active. For instance, there was no political or didactic motive in Hendricks portraying George Jules Taylor, "a beautiful skinny dude"[12] who studied Egyptology at Yale when Hendricks was there and later

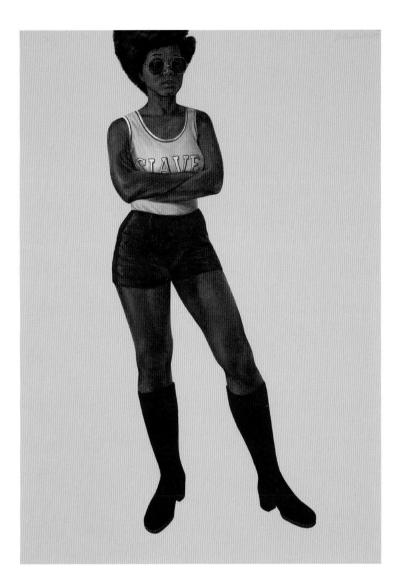

Fig. 34
Barkley L. Hendricks, *Bid 'Em In / Slave (Angie)*, 1973. Oil and acrylic on canvas, 72⅜ × 50¼ in. (183.8 × 127.6 cm). Sheldon Museum of Art, University of Nebraska–Lincoln; Olga N. Sheldon Acquisition Trust

died of complications from AIDS. Between 1971 and 1974—a time when gay and Black people were beginning to enjoy a few hard-won civil rights but received little representational consideration in art—Hendricks made four dynamic portraits of Taylor. The lithe features of the young Black male depicted on Hendricks's canvases show something of Taylor's spirit. In *George Jules Taylor* (see page 141), for instance, he is shown wearing a long black cape over a Canadian tuxedo, with his hands on his hips. He is shoeless and levitating.

"Jules was a real character," Hendricks said. "Each time he sat for me, there was a lively conversation that ensued. I found Jules to be a wonderful friend."[13] The artist also appreciated Jules's body. In this way, the series is a rare moment, in art, of a tenderness between two Black men that transcends sexual orientation and traditional codes of masculinity. The paintings expanded what Black male affection could look like, allowing something rarely or

perhaps never before seen in the depiction of sexual dynamics in Western painting, or the commercialization of Black life in popular culture, or the limited and limiting view of the Black radical movements dictating acceptable Black artistic expression. On one occasion, in 1974, Hendricks painted Jules nude as he lounged on a couch. He cheekily titled the portrait *Family Jules: NNN (No Naked Niggahs)* (fig. 35):

> Jules was about six-six, six-eight . . . I mean, he's a majestic figure as far as that's concerned, and I wanted that. I'm five-nine, and [when painting *George Jules Taylor*] I had to use a five-gallon bucket of paint to keep jumping on it to get the right proportions He was unashamed of his body, and knew that I appreciated it. It wasn't anything sexual. It's just he had a wonderful, as I said, physique.[14]

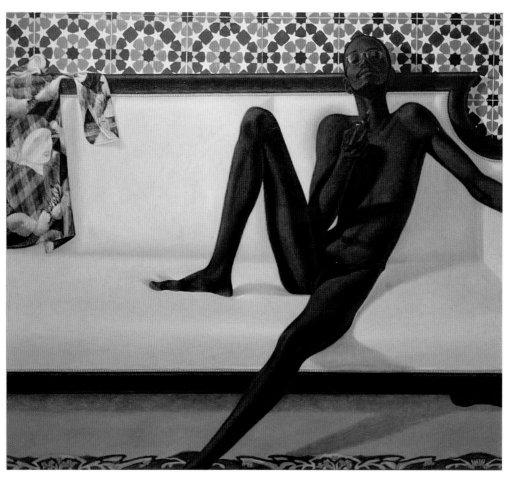

Fig. 35
Barkley L. Hendricks, *Family Jules: NNN (No Naked Niggahs)*, 1974. Oil paint on linen, 66³⁄₁₆ × 72⅛ in. (168.1 × 183.2 cm). Tate Britain, London; Presented by the American Fund for the Tate Gallery, courtesy of the North American Acquisitions Committee 2015

II.

Hendricks painted toward a new kind of realism, a type of portraiture that crystallized what critics and curators have referred to as an African American "cool." This is encapsulated by an incident, in 1976, when a tall, handsome Black man on a Philadelphia street caught Hendricks's always searching eye. With his pristine, white-collared shirt tucked into blue-jean overalls layered underneath a black jacket, Tyrone Smith was a vision of farmer chic, and Hendricks asked to take his picture. (Hendricks referred to his camera as his "mechanical sketchbook.") "The brother went into a half dozen poses,"[15] Hendricks recalled, without dropping a white bag tucked under his arm. When the impromptu shoot was over and Tyrone had stopped using the pavement as his personal runway, the crowd that had assembled gave the men a round of applause.

The street session with Tyrone resulted in *Misc. Tyrone (Tyrone Smith)* (fig. 36), a portrait in which a baby-pink background replaces the urban vista. Hendricks seems to have developed this strategy of using flat, pared-down backgrounds of vibrant, solid color—like Manet and Courbet before him—to counter the over-politicization of his subjects and to incorporate elements of abstraction, which then dominated the art world. He rarely produced portraits of his people set on the street, in his studio, in their personal spaces, or in nature. His love of the simple geometry of basketballs and of Indigenous textiles, which he saw during his student travels in West and North Africa, also informed his color-blocked backgrounds. In presenting his figures outside their surroundings, on a restricted monochrome ground, he created a kind of "visual illusion as though the person was coming off the canvas."[16] He used these solid colors—laid down in acrylic paint because oil would take a long time to dry—to heighten his figures' bodily characteristics and personalities, without distraction, to make them the focal point of the gazes directed toward them.

Through experimentation with achieving the flatness he desired, Hendricks arrived at what he called "limited palette" portraiture. In these works, the figure and ground are painted in the same primary color. In their use of color, the portrait *October's Gone . . . Goodnight* (cat. 4) and the self-portrait *Slick* (cat. 11), among others, have been compared by art historians and curators such as Zoé Whitley to the work of Black artists who immediately preceded Hendricks, including Ernest Crichlow (1914–2005), who established a Black figurative tradition, as well as the Gilded Age painter James McNeill Whistler, specifically his *Symphony in White* series (see fig. 20), for the ways they create the illusion of reflection and experiment with light on opaque surfaces.[17] Hendricks has remarked that it was his first visit to Florence, when he saw a painting of a figure wearing "a black, skin-tight outfit" by Giovanni Battista Moroni at the Uffizi Gallery, that made him see "the illusion of form and simplicity in a different light."[18] In his limited-palette works, he

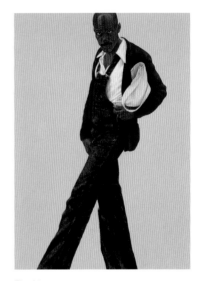

Fig. 36
Misc. Tyrone (Tyrone Smith) (cat. 9)

experimented with representing volume with a minimum of detail, while nonetheless achieving the desired perception of weight and solidity.[19]

The series of limited-palette paintings, or coordinated canvases, spanned his career, beginning with the black-on-black *My Black Nun* (see fig. 31) and concluding with the pink-on-pink portrait *Photo Bloke* (fig. 37). In images such as *Woody* (cat. 3), a yellow-on-yellow painting of a young, chocolate-skinned, male ballet dancer wearing a leotard the color of sunshine against a richly saturated, matching backdrop, Hendricks not only displays a love of playing with paint but also suggests that established conventions of representation are démodé. Woody is seen elegantly showing off the great expanse of his long upper and lower limbs. A peacock of the underrepresented sides of Black athleticism, he dances, nearly invisible against the monochrome ground. In this canvas, one sees a reaction to the social erasure of certain modes of Black masculinity and a need for "'realness' or the desire to convey authenticity" in Black culture, as Thelma Golden wrote in "My Brother," her essay for the publication that accompanied the landmark exhibition *Black Male: Representations of Masculinity in Contemporary American Art* (1994), which included portraits by Hendricks. Golden expanded:

> There is a never-ending reevaluation of what constitutes the real in black life. It is within this dialogue that Barkley L. Hendricks' paintings can be evaluated. Coming out of a desire for authentic depictions, Hendricks' works are period pieces that represent a hybrid of black cultural consciousness and contemporary art practice. With almost Photo-Realist precision, Hendricks populates his paintings with real subjects drawn from the community. His ambitious body of work provides an astounding arsenal of every vision of black masculinity possible.[20]

With the limited-palette works, Hendricks minimized backgrounds as a way to maximize figures, to emphasize their *realness*. This approach can also be seen in the many white-on-white portraits he painted, mostly from the late 1960s until the early 1980s, where he drew attention to the essences of his figures by presenting them outside the contexts that had stifled them. His figures are not set in living rooms or public spaces—settings long used to stereotype and divert focus from those who occupy them—but are divorced from their surroundings. In this way, Hendricks eases the tension between his figures and their spatial contexts. This gesture allows for a layering of formal, political, and cultural subtexts, while maintaining a chic detachment from the city street that had been used to pathologize and make disappear the disempowered people he painted.

For Hendricks, setting mattered less than what his figures had done to transcend it. His subjects showed up in the world the way he found them, and he wanted to honor that.[21] This is

Fig. 37
Barkley L. Hendricks, *Photo Bloke*, 2016. Oil and acrylic on linen, 72 × 48 in. (182.9 × 121.9 cm). Private collection

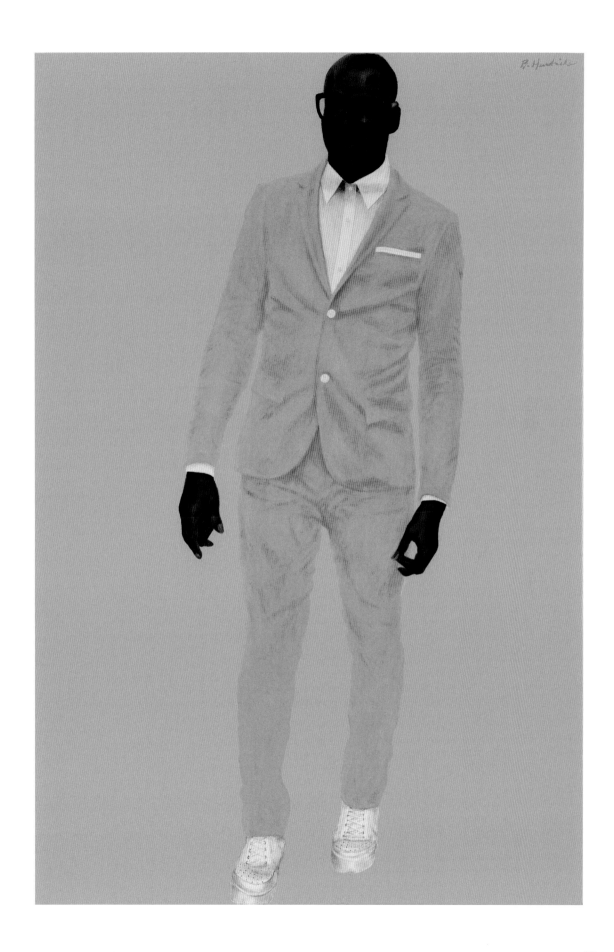

not to say the images are without atmosphere. For instance, the large-scale, white-on-white portrait *What's Going On* (fig. 39) captures the mood of the early 1970s in Black America. The canvas features five figures: four clothed figures—including three Black dandies—in white suits and floppy wide-brim hats, looking in various directions, and a nude Black woman, caught in profile. The woman's naked presence evokes that of the nude female in Edouard Manet's *Le Déjeuner sur l'herbe* (1863), as art historian Huey Copeland has written.[22] Like Manet's woman, she does not seem to belong among the clothed figures, but she also seems just as confident as the fully clothed woman in the frame, who looks like the First Lady of the local church. The work is titled after Marvin Gaye's 1971 classic, and the juxtaposition of the clothed and the naked, the sacred and the profane, perfectly captures the chaos and confusion of the street that we hear in the opening moments of the protest song, which summed up a period when it was difficult to tell if we were experiencing communal upheaval or uplift.

Even as the figure and ground merge in Hendricks's white-on-white pictures, like *What's Going On, Sophisticated Lady* (fig. 38), and *Dr. Kool* (cat. 5), the ebony hands, faces, and hair of the subjects always stand out, emerging from a sea of whiteness. Among the white-on-white pictures is *Omarr* (cat. 15), an image of a Black man in a long, pallid, puffy winter coat, set against a milky backdrop. The figure's back is turned to us, suggesting that he is withholding himself, that he is free from the kind of dominant gaze that would deny he is real. The diamond-shaped, porthole-like format of the canvas heightens the tension between viewer and subject and, taken together with his almost spacesuit-like coat, suggests he is a kind of Afrofuturist vision.

These portraits also seem to have been a way for Hendricks to show that he and his Black subjects understood America's limited palette, the way American culture all too often sees the world without nuance, in black and white. Thelma Golden once remarked to Hendricks, "In your paintings you offered a much more complex way of being. You captured in your paintings your subjects' sense of themselves, and the way in which they look at the world." His response: "It's not what everyone sees given where we are on the planet, as far as the land of the free, the home of the brave."[23] Perhaps this is why in *Miss T* (cat. 2), a painting of an old girlfriend, he flips the script to further explore the tension between what is seen and what is unseen but nonetheless real. A Black woman with a perfectly coiffed afro and in a black dress, *Miss T* is set against a white ground. The portrait evokes not only notions of positive and negative space and color but also the novelist Zora Neale Hurston's biting summation of her experience of race: "I feel most colored when I am thrown against a sharp white background."[24]

Beyond interrogating America's black-and-white palette, Hendricks's all-white figures evoke style codes Black people pioneered—with the advent of Black dandyism in

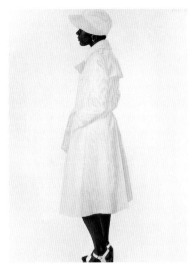

Fig. 38
Barkley L. Hendricks, *Sophisticated Lady (Barbara Perry)*, 1976. Oil, acrylic, and Magna on canvas, 60 × 48 in. (152.4 × 121.9 cm). Private collection

ANTWAUN SARGENT

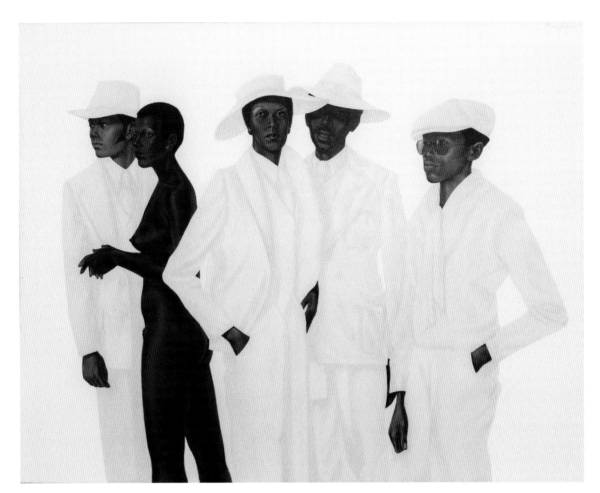

Fig. 39
Barkley L. Hendricks, *What's Going On*, 1974. Oil, acrylic, and Magna on canvas, 65¾ × 83¾ in. (167 × 212.7 cm). Private collection

eighteenth-century England, Cab Calloway's ushering in of the zoot suit, and the single-color dressing of early hip-hop rappers, church choristers, the Santeros, pimps, and priests. As a fashion style, color-blocking transcends distinctions of class and power within Blackness; it is found at every level of Black life. With this shared aesthetic, Black people have used monochromatic dressing to maintain connections to their West African heritage, to signify faith and value, access and excess.

In making backdrop and fashion one, Hendricks enriches his canvases through ambiguity or multivalence. In *Steve* (fig. 40), the young man's white trench coat over a matching dress shirt and pants references the way Black folks wear white to church to signify purity, and to all-white parties to represent uniformity and togetherness. The fact that you cannot quite pin down whether Steve is going to church or to a club—or perhaps to both in the span of a late Saturday night that turns into an early Sunday morning—was Hendricks's point.

Fig. 40
Steve (cat. 10)

In drawing on the history of Western painting, style codes such as color-blocking, and the art movements ascendant in the middle of the twentieth century, Hendricks's portraits present unique visions of the everyday figures he encountered. In breaking with the cultural orthodoxy of the mid-twentieth century, his most pro-lific figurative period, he unwittingly painted toward a future of representation that has now arrived. Hendricks's way of messing with painterly conventions to focus on the beauty often denied to him and his sitters shows how he responded to what Huey Copeland calls "a crisis within representation."[25] In reckoning with that loaded idea, the artist created new ways for Black figures to occupy space within the Western tradition of painting.

Hendricks's singular vision of what paint can and should do has been an important antecedent for subsequent generations of Black artists, among them, Nick Cave (b. 1959), Njideka Akunyili Crosby (b. 1983) (fig. 41), Jennifer Packer (b. 1984), and Henry Taylor (b. 1958). With painters like Hendricks and Kerry James Marshall (b. 1955) (fig. 42) as models, these artists have ushered in a new golden age of Black figurative painting. Painters like Mario Moore (b. 1987), Devan Shimoyama (b. 1989), and Jeff Sonhouse (b. 1968) (fig. 43) grapple with the responsibility of representation and using painting as a tool to address the broader issues of identity, gender, and personal and social politics. They are also reclaiming the Black figure for themselves, sometimes without caring about broader acceptance. Sonhouse, who often creates mixed-media portraits of Black figures that optically camouflage them within their envi-ronment, acknowledges: "I paint the black figure because it's mine. This is who I am. I'm not motivated by a sense of being seen.

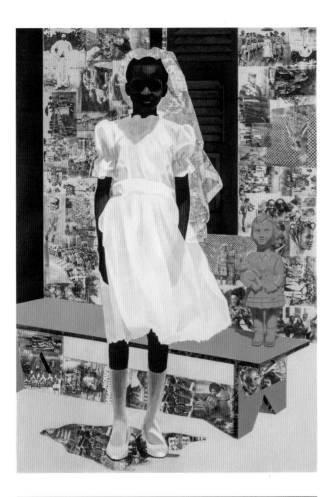

Fig. 41
Njideka Akunyili Crosby, *"The Beautyful Ones" series #4*, 2015. Acrylic, color pencil, and transfers on paper, 61 × 42⅛ in. (154.9 × 106.7 cm). Private collection

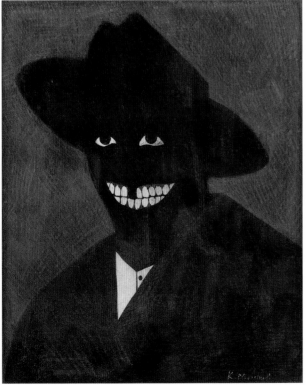

Fig. 42
Kerry James Marshall, *A Portrait of the Artist as a Shadow of His Former Self*, 1980. Tempera on paper, 8 × 6½ in. (20.3 × 16.5 cm). Los Angeles County Museum of Art

I really don't give a damn if I'm included or have been omitted in some sense."[26]

The historical omission of the Black figure informs images by Kehinde Wiley (b. 1977) of men and women seen on the streets throughout the African diaspora. Painted making dramatic, empowered gestures, often in streetwear, many of these figures are set against ornate backdrops that echo the Renaissance, African textiles, and the Baroque. Paintings such as his *St. Gregory Palamas* (fig. 44), an updating of the Byzantine icon as a shirtless, tattooed Black male against a gold-leaf ground, reflect the penchant he shares with Hendricks for experimenting with gilding and examining the secular in relationship to the religious.

Like Hendricks, painters such as Wiley and Mickalene Thomas (b. 1971) present the desires and other personal qualities of their subjects without moralizing or overlaying ideas about commodification or social progress. Their subjects are real, complicated, flawed. Central to Hendricks's work was a rejection, through style, of the dominant gaze. Thomas's reimaginings of the Muses of classical mythology as self-assured Black women contain something of Hendricks's self-fashioning in that Thomas reaffirms his sitters' taste and class positionality. In *Le Déjeuner sur l'herbe: Les trois femmes noires* (fig. 45), Thomas creates a bedazzling, textured image of three Black women at a picnic that is rooted in a 1970s aesthetic pioneered by Hendricks. Recasting Manet's troubling nineteenth-century canvas as an affirming moment of sisterhood, Thomas claims a space for the Black body in art-historical discourse and supplants the dominant gaze with her own. She explains:

> I was looking at Western figures like Manet and Courbet to find a connection with the body in relationship to history. Because I was not seeing the Black body written about art historically in relation to the white body and the discourse—it wasn't there in art history. And so I questioned that. I was really concerned about that particular space and how it was void. I wanted to find a way of claiming the space, of aligning my voice and art history and entering this discourse.[27]

Hendricks's refiguring of Black subjects by challenging the supposed, or imposed, realities that disfigured them by assigning them labels they did not give themselves has become a full-fledged project in contemporary Black portraiture. Painters such as Jordan Casteel (b. 1989), who paints people she spots on the streets in ways that allow their urban and domestic landscapes to complement who they are, are creating their own visions of community that, like Hendricks, rely on a questioning of color both formally and socially. Where Hendricks used color-blocked backgrounds to allow his subjects to be seen, Casteel plays with the color of the body. Her *Visible Man,* an early series of intimate nudes of Black men painted in shades of blue, purple, red, and green in

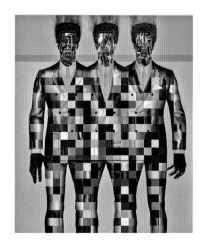

Fig. 43
Jeff Sonhouse, *One Man Gang*, 2021. Oil and burnt match sticks on canvas, 98¼ × 82⅜ in. (249.6 × 209.2 cm).

Fig. 44
Kehinde Wiley, *St. Gregory Palamas*, 2014. 22k gold leaf and oil on wood panel, 40 × 24 in. (101.6 × 61 cm). Collection Edward Tyler Nahem, New York

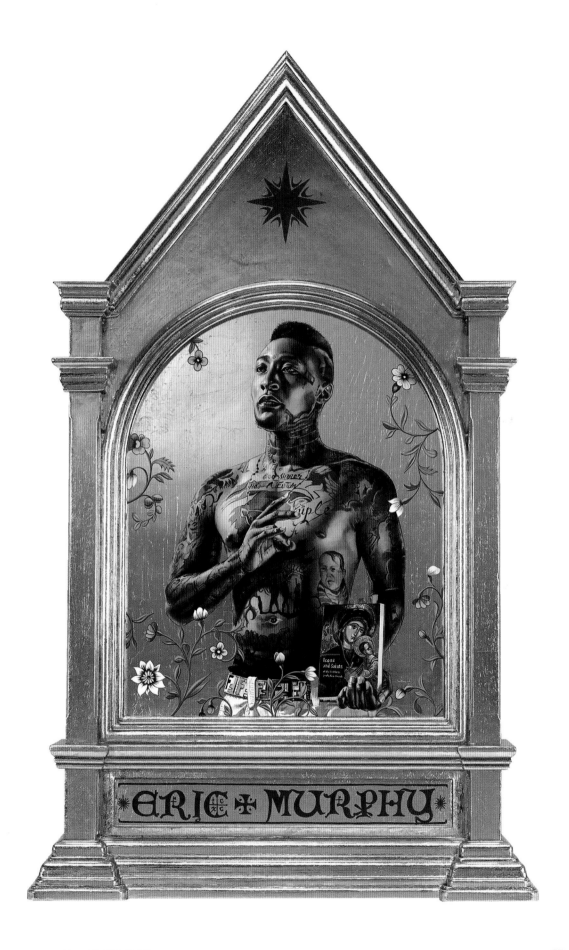

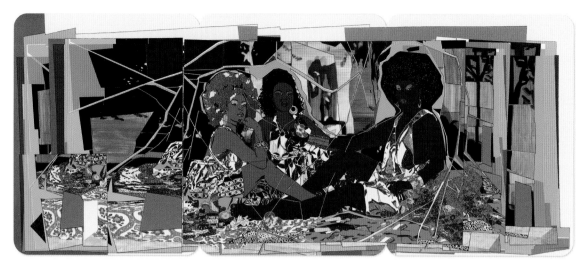

Fig. 45
Mickalene Thomas, *Le Déjeuner sur l'herbe:
Les trois femmes noires*, 2010. Rhinestones,
acrylic, and enamel on panel, 120 × 288 in.
(304.8 × 731.5 cm). Private collection

their personal interior spaces, engages in dialogue with
Hendricks's naked depictions of himself. Casteel explains:

> For years I had been watching black men around me being
> portrayed as something different than what I knew and
> experienced. The world saw those that I loved most—my
> brothers, my father, my friends, family, and lovers—as being
> less than what they are. In my paintings of the black male
> nude, I was directly challenging the barrier clothing creates
> for black bodies I have found that clothing on a black
> male body can in fact create a distraction for a viewer in
> that it comes with so many assumptions about race, class,
> and culture.[28]

The flat monochrome grounds against which Hendricks
situates his figures are evoked in the canvases of Black subjects
by Amoako Boafo (b. 1984), Amy Sherald (b. 1973), and Peter
Uka (b. 1975). Sherald's official portrait of Michelle Obama (fig.
46), whom she considers "an archetype,"[29] features a pale baby-
blue background that echoes the acrylic color-field flatness of
Hendricks's *Hasty Tasty* (see fig. 33). Sherald, whose portraits
are conceptually informed by old photographs, depicts all of
her subjects with gray skin. In this way, her use of the grayscale
technique echoes Hendricks's use of the photographic. As pre-
viously discussed, Hendricks, who studied with Walker Evans,
created images rooted in photorealism. Like Sherald, Hendricks
used the camera to draw connections to a rich history of Black,
lens-based portraiture that documented the community and

Fig. 46
Amy Sherald, *Michelle LaVaughn
Robinson Obama*, 2018. Oil on linen,
72⅛ × 60⅛ in. (183.2 × 152.7 cm).
National Portrait Gallery, Smithsonian
Institution, Washington

allowed it to assert control over images of Black figures long before they were seen as worthy of being painted.

Hendricks's influence is also seen more broadly in the work of Black image-makers such as Awol Erizku (b. 1988) (see page 144), Rashid Johnson (b. 1977) (see page 146), and Deana Lawson (b. 1979). Their work presents myriad visions of Black desire and beauty in visual constructions that inhabit a space between the commercial and the conceptual. Erizku belongs to an emerging group of Black photographers I have termed the New Black Vanguard, a loose global network of portraitists—from Lagos to Los Angeles—who use fashion as a device in conceptual art that addresses their absence from the official telling of the history of photography. The photography of artists such as Renell Medrano (b. 1992), Tyler Mitchell (b. 1995) (fig. 47), and Ruth Ginika Ossai (b. 1986), among others, aims not only to make the images of Black people less censorious but also to formulate new definitions of glamor and attitude that are culturally specific but have universal allure.[30]

Erizku, for instance, has photographed his sister, actors, rappers, friends, and contemporary pop icons including Beyonce against solid-color backdrops. His inspiration lies, in part, in the canonical history of representation and erasure that also informed Hendricks's commitment to portrait-making. In his photograph *Girl with a Bamboo Earring* (fig. 48), Erizku replaces Vermeer's subject in *Girl with a Pearl Earring* (1665) with his sister. She gazes confidently at the camera as a modern icon of beauty. Her accessory, the gold bamboo earring, locates her beauty and worth where Hendricks found his: in urban Black communities. In using style as a device, both Hendricks and Erizku "not only illustrate the state of being sharp," as the art historian Richard J. Powell argued, but also epitomize "something fundamentally artistic in the way the people depicted present themselves to the world at large. This art of self-representation is far more intangible and multivalenced than mere style for style's sake."[31]

Fig. 47
Tyler Mitchell, *Chad and Dad*, 2021.
Archival pigment print, 50 × 40 in.
(127 × 101.6 cm).

Fig. 48
Awol Erizku, *Girl with a Bamboo Earring*,
2009. Digital chromogenic print, 65 × 50 in.
(165.1 × 127 cm). Edition of 5.

NOTES

1 Jesus said to his disciples, "It is inevitable that stumbling blocks will come, but woe to the one through whom they come! It would be better for him to have a millstone hung around his neck and to be thrown into the sea than to cause one of these little ones to stumble"; Luke 17:2.
2 Hendricks 2016b.
3 Hendricks 2016b.
4 Neal 1968, 28. Despite Neal writing that the movement eschewed "protest" in art because it appealed to "white morality," the visual artists who came to be associated with BAM largely relied on highly politicized figuration that sought to present positive, and often didactic, imagery of Black leaders, both national and communal, as models of Black morality, radicality, and *protest*. There were works that showed historical figures and Black Panthers, such as Angela Davis, as the seeds of revolution and freedom. The agitprop of the period, such as Emory Douglass illustrations created for the *Black Panther Party Newspaper*, helped spread the Black Power concept and present clear messages of racial uplift through the use of murals and billboards across Black communities. Chicago's *The Wall of Respect*, which garnered national media attention because it was a mural made by local artists on the city's South Side, honored the contributions of Black heroes who aided in the struggle for Black liberation, such as Marcus Garvey, Nat Turner, Gwendolyn Brooks, and Nina Simone.
5 Neal 1968, 85.
6 Hendricks quoted in Whitley 2017–20, 198.
7 Kramer 1977.
8 Durham and other cities 2008–10, 104.
9 Hendricks 2008–10, 59.
10 Hendricks 2008–10, 59.
11 Durham and other cities 2008–10, 107.
12 Hendricks 2016a.
13 Hendricks 2008–10, 63.
14 Anna Arabindan-Kesson 2017c.
15 Hendricks 2016b.
16 Hendricks 2016b.
17 Whitley 2017–20, 198.
18 Hendricks 2016b.
19 Durham and other cities 2008–10, 105.
20 New York 1994–95, 42.
21 The backgrounds in his figurative portraits stand in contrast to his plein-air landscapes of Jamaica. In those landscapes, the subject is what is often considered the background: nature. For people, these vistas are mise-en-scènes to enter, the context in which their daily dramas play out. What does it mean for a portrait painter to bring the background forward? To have all that is natural flourish as the figure, unbounded?
22 Copeland 2009.
23 Hendricks 2008–10, 59.
24 Hurston 1928.
25 Copeland 2009.
26 Sargent 2017.
27 Thomas 2018, note 3.
28 Jordan Casteel in conversation with the author, October 2015.
29 Sargent 2017.
30 Sargent 2019, 11.
31 Powell 2008, 4.

Catalogue

ENTRIES BY
AIMEE NG

Many of the comparative photographs—as well as the one drawing—illustrated in these entries are published here for the first time, courtesy of the Barkley L. Hendricks Estate, to which we are extremely grateful for allowing access to the photographic and documentary archive. The illustrations are included here to represent the range and richness of Hendricks's photography practice as it pertains to his production of painted portraits. The drawing (see figs. 106, 107) and certain photographs (see fig. 61) tell us that the period between his interest in a subject and his execution of a painted portrait could span a number of years.

To create his portraits, Barkley L. Hendricks worked from studying live models in his studio, from photographs he took of models, and at times from both. He also used found images and objects. The absence of related photographs to a painting does not necessarily indicate that he did not create any; they may be untraced. Nor does the inclusion of related photographs indicate that the artist did not also study the same models from life. In addition to black-and-white and color film photography, Hendricks also carried a Polaroid camera, often offering the instantly produced images as a gift to those he asked to photograph on the street.

1

LAWDY MAMA

1969. Oil and gold leaf on canvas,
53¾ × 36¼ in. (136.5 × 92.1 cm).
Studio Museum in Harlem, New York;
Gift of Stuart Liebman, in memory
of Joseph B. Liebman

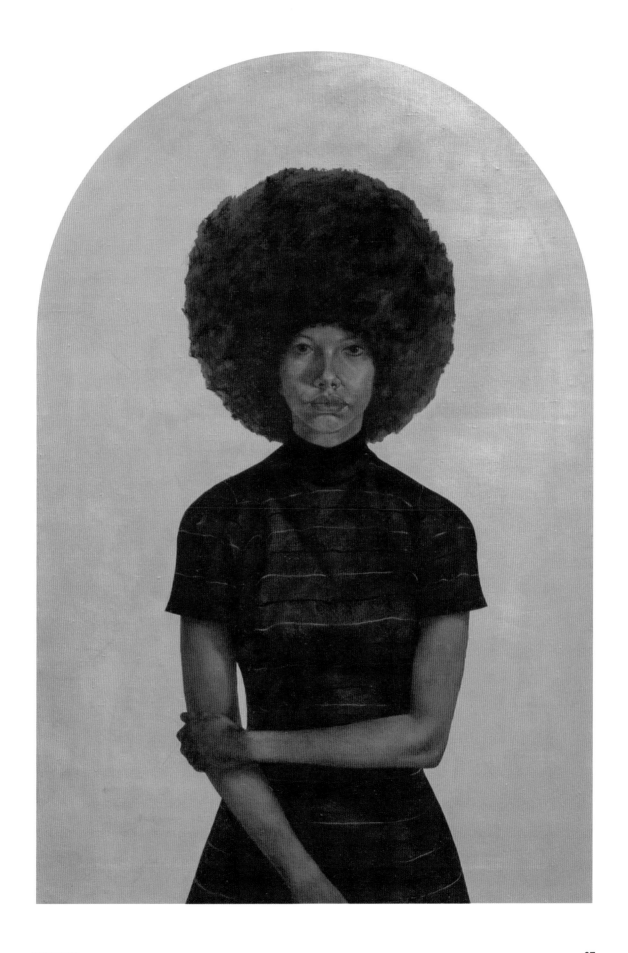

About this work, Hendricks wrote:

> *Lawdy Mama* was the portrait of my second cousin twice
> removed, Kathy Williams, not Angela Davis or Kathleen
> Cleaver. The title was inspired by lyrics from the songbook
> of Nina Simone about "sistas." My love of Greek and Roman
> icons had a great deal to do with the materials and com-
> position of this work. In fact it was the first large-scale
> gold-leafed painting of my career. Beyond the inspiration it
> provided a wealth of knowledge and experience about the
> craft and art of gold leafing. The lunette top was one of four
> prepared after I cut two plywood circles in half. Three went
> to a basketball composition called *Father, Son, and . . .* [see
> fig. 30]. The fourth was *Lawdy Mama*.[1]

Regarding his experience with the gold leafing technique:

> Usually gold leafing is done on a surface that is rather rigid
> or even hard; it's done on panel. Many of the major icons
> were done on very hard surfaces to ensure that they could be
> burnished, or made shiny—that they could be gone back into
> with tools that would give a kind of glow or reflective quality.
> I was using canvas, and canvas didn't have that rigid back sur-
> face on which to use a burnisher. What came through was
> the texture of the canvas. And that was cool with me. I didn't
> need to burnish it or make it shinier than it was. . . . [G]old is
> very finicky, very delicate. The slightest wind or heavy breath
> will send it fluttering all over the place. I had to close all the
> windows so there was no air circulating. I had started with
> my air conditioner on and a window open and I realized the
> slightest gust would crinkle it up so it wouldn't work.[2]

A photograph of the subject (fig. 49) was published in the cata-
logue accompanying *Birth of the Cool* with the following caption:
"Photograph of Kathy Williams (subject of *Lawdy Mama*) in studio
at 1605 Race Street, Philadelphia, 1970."[3]

No photographs of the model taken in preparation for the painting
are known.

Select exhibitions: Hartford 2002; New York 2005; Albany 2006;
Durham and other cities 2008–10; Brooklyn, Hanover, and Austin
2014–15; New York 2017; San Francisco and other cities 2019–21.

NOTES

1 Durham and other cities 2008–10, 105. According to Salmon
 (2010, 27), Kathy Williams passed away in 2009.
2 Pedro 2016.
3 Powell 2008–10, 42.

Fig. 49
Photograph by Barkley L. Hendricks of
Kathy Williams, 1970. Courtesy the Estate
of Barkley L. Hendricks

2

MISS T

1969. Oil and acrylic on canvas,
66⅛ × 48⅛ in. (168 × 122.2 cm).
Philadelphia Museum of Art, Philadelphia;
Purchased with the Philadelphia
Foundation Fund, 1970

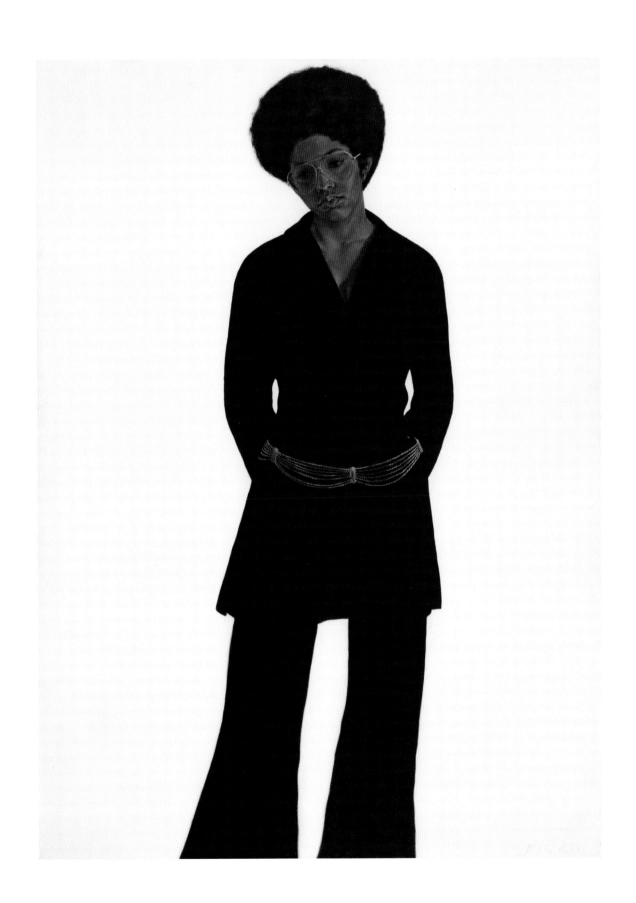

Described by Hendricks as the "first in a series of former lovers/
friends," this was also the first painting in which the artist com-
bined oil and acrylic on the same canvas.[1] Looking back on the
portrait some fifteen years after painting it, Hendricks responded
to a query regarding incidents related to its making and subsequent
history by commenting, "Too many to name now—it's just a very
important painting to me."[2] About its inspiration, he wrote:

> After my first visit to Rome, Italy, I returned with a head full
> of inspirations besides the icons and gold leaf. The paintings
> in the Uffizi in Florence were mindblowers. Especially one by
> Giovanni [Battista] Moroni [see fig. 3]. The figure in a black,
> skin-tight outfit made me see the illusion of form and simplic-
> ity in a different light. I realized from that painting that I could
> handle volume with a minimum of detail and still pull off the
> desired perception of weight and solidity in a style I had never
> worked with before. *Miss T* and *J.S.B. the III* [see fig. 4] are a
> direct by-product of that influence.[3]

About the model—Robin Taylor, a former girlfriend—the artist
wrote: "Several paintings come with good color besides what's
on their canvases. Robin (*Miss T*) scared the shit out of my mother
when she told her, 'If she couldn't have me, no one would.'"[4]

No photographs of the model taken in preparation for the painting
are known.

Select exhibitions: Philadelphia 1969; Greenville, Charleston, and
Columbia 1975; Durham and other cities 2008–10; Philadelphia
2015; Philadelphia 2021.

NOTES

1 Questionnaire completed by Hendricks following the
 painting's acquisition by the Philadelphia Museum of Art
 (PMA), dated August 28, 1984; PMA curatorial file.
2 Questionnaire dated August 28, 1984; PMA curatorial file.
3 Durham and other cities 2008–10, 105.
4 Durham and other cities 2008–10, 98.

Fig. 50
Photograph by Barkley L. Hendricks of
the installation of *Birth of the Cool* at the
Nasher Museum of Art, 2008. Courtesy
the Estate of Barkley L. Hendricks

Hendricks, walking behind curator Trevor
Schoonmaker and Susan Hendricks,
captures the reflection of *Lawdy Mama* in
the glass of *Miss T* on the left wall. Also
pictured, kneeling at left, is conservator
Ruth Cox.

3
WOODY

1973. Oil and acrylic on canvas,
66 × 84 in. (167.6 × 213.4 cm).
Baz Family Collection

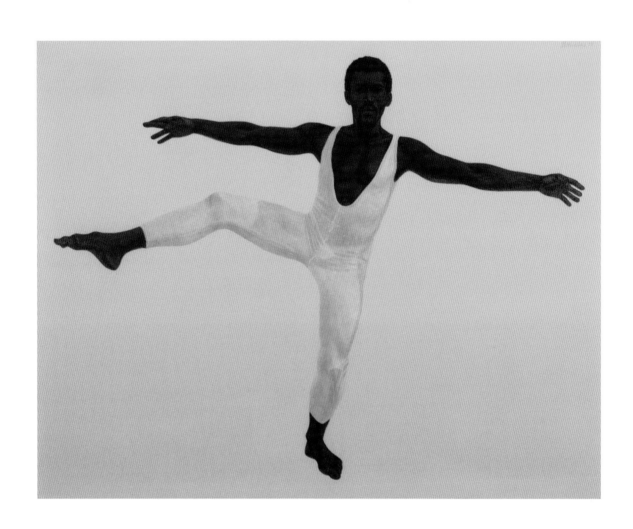

The subject has recently been identified by Richard J. Powell as Woodruff (Woody) Wilson, a dancer of Jamaican descent with the American Dance Festival, which took place on the grounds of Connecticut College in New London, Connecticut. The artist was associated with Wilson through Adrienne Hawkins, a dancer and former girlfriend (and a model for a number of his works).[1]

Hendricks modified Woody's unitard (as seen in the photographs) by changing the blue-gray cuffs around the ankles to yellow, and by creating a deep-V neckline, which generally follows the contours of a red strap visible in the photographs at the right and left shoulders, and under the unitard at the chest. The function of the red strap is uncertain; it may be a personal accessory. The artist also eliminated the model's necklace and ring and a Band-Aid worn on his proper left index finger. The photographs' grassy setting is probably the college campus.

Select exhibitions: Philadelphia 1974; Greenville, Charleston, and Columbia 1975; New Orleans 2017–18.

NOTE

1 Richard J. Powell in Whitley forthcoming.

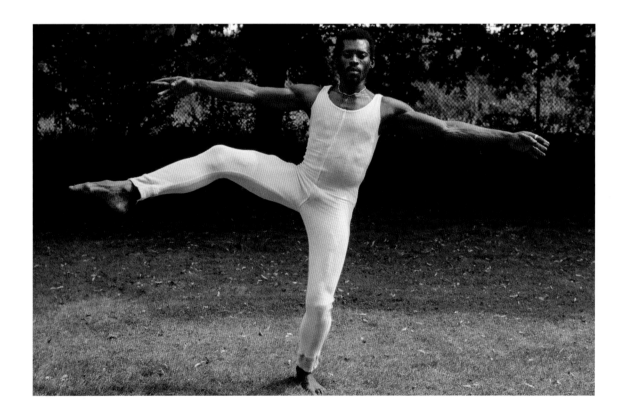

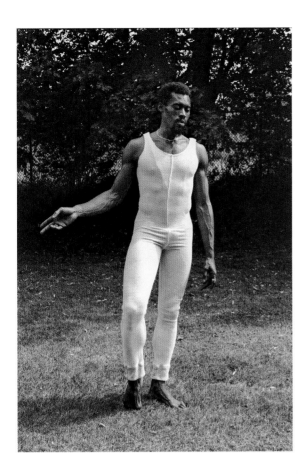

Figs. 51–54
Photographs by Barkley L. Hendricks
of Woodruff (Woody) Wilson, ca. 1973.
Courtesy the Estate of Barkley L.
Hendricks

In a grassy setting with trees and fencing
visible in the background, the artist
captures the model in various poses, as
well as his facial features in closer shots.

4

OCTOBER'S GONE . . . GOODNIGHT

1973.[1] Oil and acrylic on canvas,
66 × 72 in. (167.6 × 182.9 cm).
Harvard Art Museums / Fogg Museum,
Cambridge; Richard Norton Memorial Fund

Hendricks noted that this painting—along with *Sir Charles, Alias Willie Harris* (see fig. 9); *Bahsir* (cat. 6); and *Northern Lights* (cat. 8)—"sprang from that direct influence" of the Three Graces theme. "I also felt that one pose was not enough for those particular subjects," he wrote.[2] The birthmarks on the model's neck and arm, visible in photographs (fig. 56), are omitted in the painting, which also excludes the model's bracelets and rings and adds eyeglasses and red nail polish.

About the making of the painting, the artist recounted:

> This is dedicated to letters I was getting when I was teaching at Connecticut College [W]hen I first started, I used to get letters from this student who was always anonymous. And she ended with the title, or it's now a title, I call it 'October's Gone . . . Goodnight': these are beautiful, poetic letters, which I treasure, from someone I didn't know. She helped me find out who she was, and I had her to pose for me. She was married at the time, and when she told her husband that she was posing for an artist, he came up to sort of see what was going on. And I told him, 'I am interested in painting, not messing around,' and the brother never came back. And I finished the piece.[3]

Select exhibitions: New London 1973; New York 1980; Bridgeport 1988; Philadelphia 1992; New London 2001; Cambridge 2017–22.

NOTES

1 An archival document related to the painting gives the date: January 8, 1973.
2 Durham and other cities 2008–10, 105.
3 Hendricks 2016b.

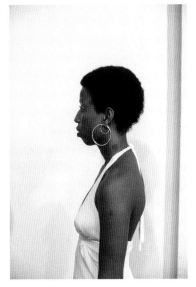
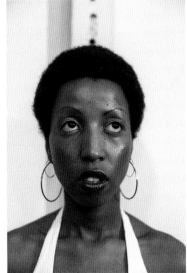

Figs. 55–59
Photographs by Barkley L. Hendricks
of the unidentified model for *October's
Gone . . . Goodnight*, ca. 1972. Courtesy the
Estate of Barkley L. Hendricks

In the artist's studio, Hendricks captures
the model from the three angles at which
she is presented in the painting, in which
he edited out her jewelry and birthmarks
and added glasses and red nail polish.

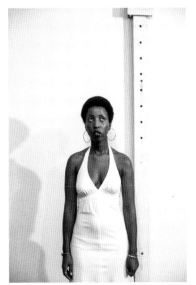
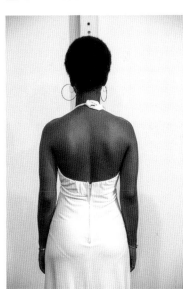

5

DR. KOOL

1973.[1] Oil and acrylic on canvas,
72¾ × 52¾ in. (184.8 × 134 cm).
Collection Clark Family

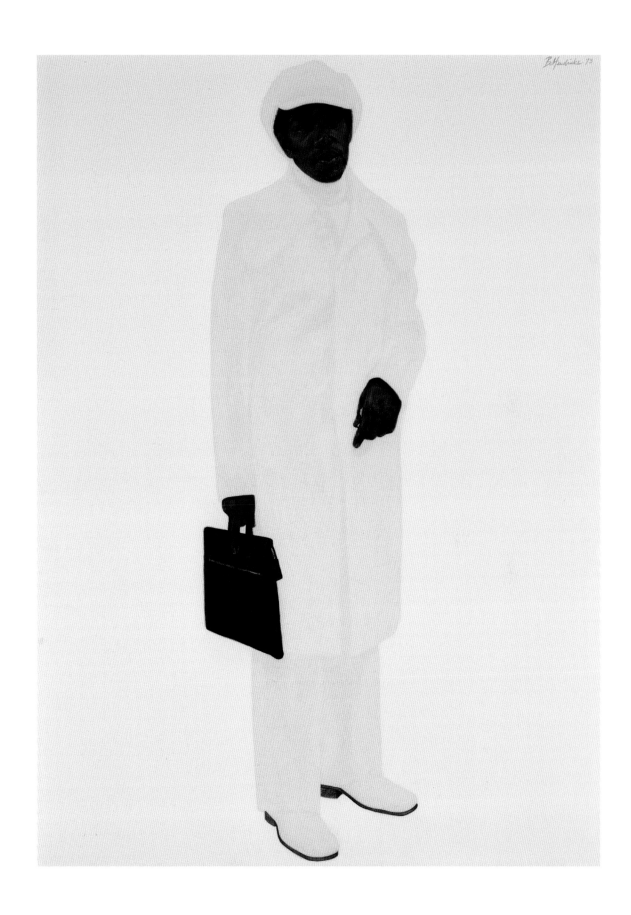

October's Gone . . . Goodnight (cat. 4) is the earliest of Hendricks's white-on-white, limited-palette paintings. He described his encounter with the unidentified subject of *Dr. Kool*, which took place several years before he executed the painting (and before *October's Gone . . . Goodnight*): "One time I met this guy on the street in Philadelphia dressed completely in white holding a black briefcase—a white suit, hat, shoes. I was so attracted to his sense of style I asked if [I] could photograph him. This was around 1970. I kept the photograph for two or three years, then made a painting using white acrylic, oil and Magna paint for a total monochromatic effect. I called it Dr. [K]ool."[2]

According to a 1976 article in *American Artist*, Hendricks's white-on-white effects began with basketball still lifes, where he painted balls floating and arcing in air: "In a white-on-white painting of a black person, the person's head floats much the same way his basketballs did."[3] Hendricks is quoted as saying, "These paintings [white-on-white limited-palette works] are not radically different from the earlier [basketball] ones. . . . To me, flying is the ultimate freedom." A print of the photograph (fig. 61) was exhibited in New York in 1980.[4] Hendricks omitted the decorated cross pendant visible in the photograph but retained the detail of the white object—perhaps paper or a handkerchief—crumpled in the model's hand.

Select exhibitions: Greenville, Charleston, and Columbia 1975; Durham and other cities 2008–10.

NOTES

1 An archival document related to the painting gives the date: April 3, 1973.
2 Genocchio 2008. An archival document describes the media used as oil and acrylic, without mention of Magna.
3 Mangan 1976, 36.
4 New York 1980, no. 34.

Fig. 60
Photograph by Barkley L. Hendricks of the artist with paintbrush in hand standing between *Dr. Kool* and *Mayreh (Mary Sheehan)*, ca. 1973. Courtesy the Estate of Barkley L. Hendricks

Fig. 61
Photograph by Barkley L. Hendricks of the unidentified model for *Dr. Kool*, ca. 1970. Courtesy the Estate of Barkley L. Hendricks

The artist exhibited this photograph among the works shown in his 1980 solo show at the Studio Museum in Harlem. For the painting derived from this image, he omitted the model's large cross pendant.

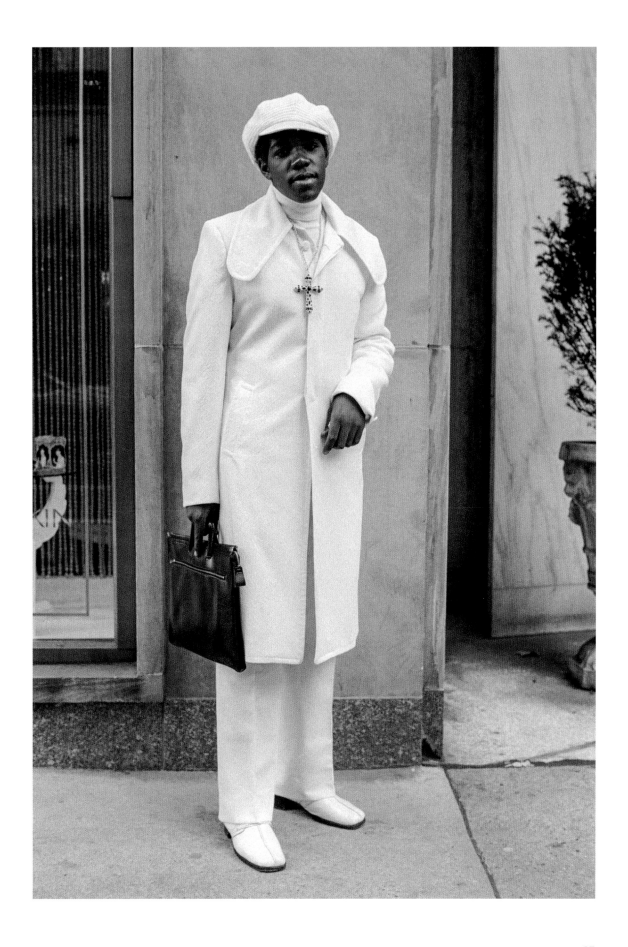

6

BAHSIR
(ROBERT GOWENS)

1975.[1] Oil and acrylic on canvas,
83½ × 66 in. (212.1 × 167.6 cm).
Nasher Museum of Art at Duke University,
Durham, N.C.; Museum purchase
with additional funds provided by Jack Neely

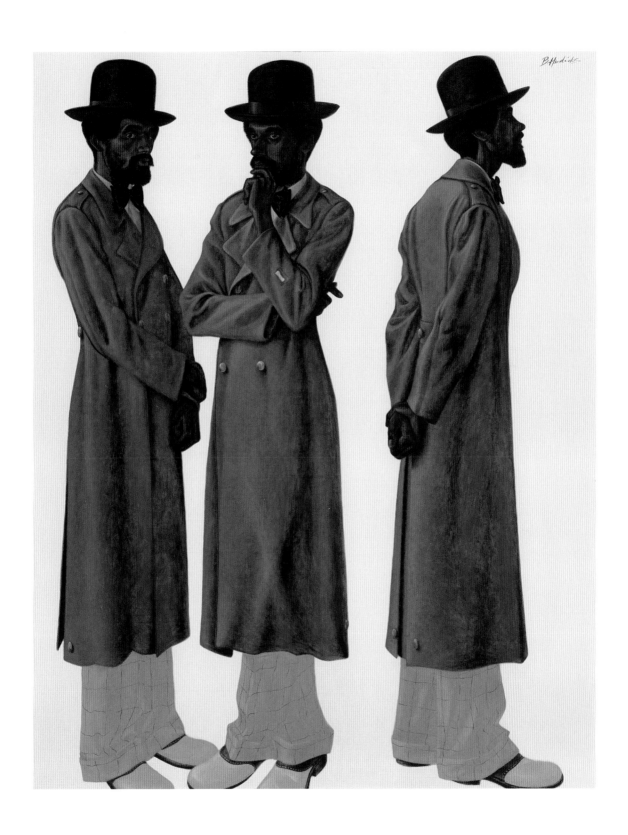

Hendricks described the sitter for this triple portrait as "a good friend from Philadelphia who came up to New London" to visit his studio on State Street.[2] Color photographs taken by the artist show him there, set against a white sheet, though the background of the finished painting is a complex light green. In depicting the subject's long coat and pants, Hendricks combined brushwork, layered painting, and the weave of canvas to create varied textures. In the eyes of the central portrait, he rendered with minute precision the tiny reflection of the arched windows of his studio (as was captured in photographs; see fig. 65 and page 13). Unlike the other works inspired by the Three Graces motif (cat. nos. 4 and 8 and fig. 9), in *Bahsir* two of the figures slightly overlap, enhancing the illusion of bodies in space against the flat, abstracted background.

As was often the case, Hendricks's final painting differed in small ways from his preparatory photographs; here, he added a bowtie and changed the color and pattern of the shirt. In one photograph (fig. 62), the sitter wears eyeglasses.

Bahsir is among the tallest figural works Hendricks produced. Recalling his process, the artist noted that he stood on a paint bucket to reach the upper part of the canvas and paint the heads and hats.[3]

Select exhibitions: Boston 1975–76; Durham and other cities 2008–10.

NOTES

1 An archival document related to the painting gives the date: June 3, 1975.
2 Hendricks 2016b.
3 In conversation with Susan Hendricks, 2023.

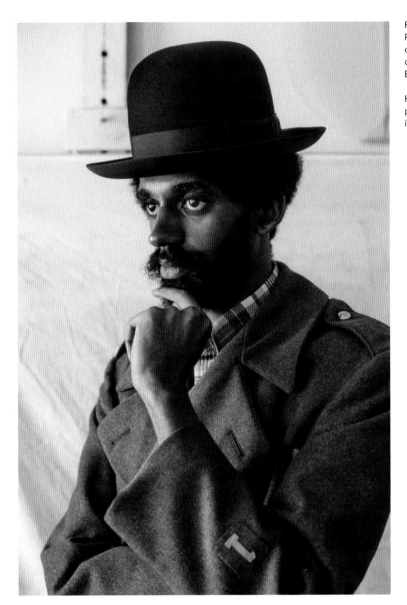

Figs. 62–65
Photographs by Barkley L. Hendricks
of the model for *Bahsir (Robert Gowens)*,
ca. 1975. Courtesy the Estate of
Barkley L. Hendricks

Hendricks experimented with various
poses for his subject, including an option
in which he wore glasses.

Fig. 66
Photograph by Barkley L. Hendricks of
the artist standing in his studio with
Jackie Sha-La-La (Jackie Cameron), 1975;
North Philly Niggah (William Corbett),
1975; and a partial view of *Bahsir (Robert
Gowens)*, 1975, ca. 1975. Courtesy the
Estate of Barkley L. Hendricks

7
BLOOD
(DONALD FORMEY)

1975.[1] Oil and acrylic on canvas,
72 × 50½ in. (182.9 × 128.3 cm).
Private collection

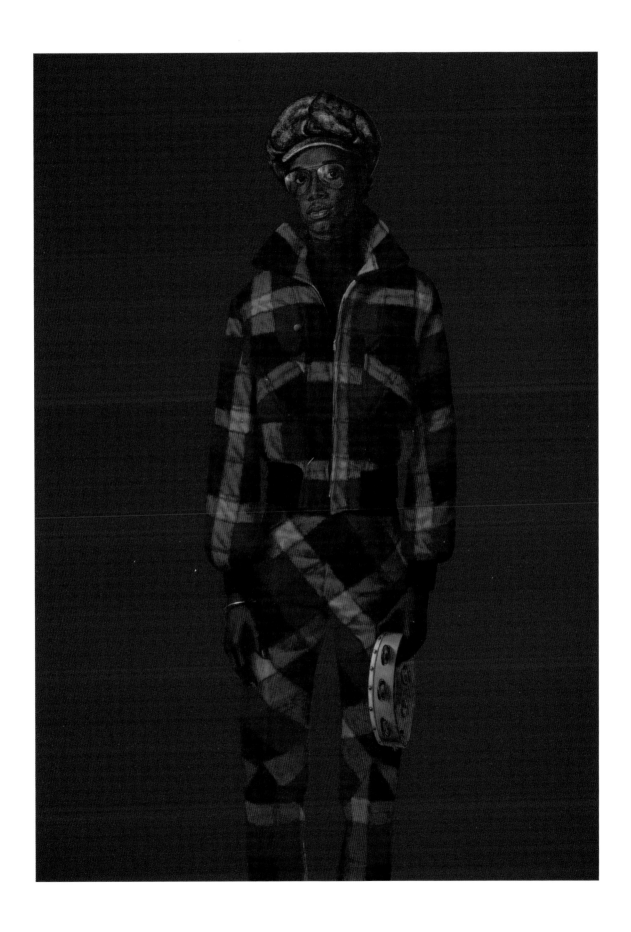

Donald Formey was a former student of the artist, who taught at Connecticut College from 1972 to 2010.[2] Hendricks photographed the model against a white backdrop in his studio. In the painting, he transformed Formey's blue pants (fig. 69) to match the pattern of the jacket. He also added glasses and a tambourine.

Select exhibitions: New York 1976; Loretto, Erie, and Doylestown 2001; New London 2001; London and Walsall 2005; Durham and other cities 2008–10; New Orleans 2017–18.

NOTES

1 An archival document related to the painting gives the date: June 15, 1975.
2 Valentine 2019. From an interview with Kenneth Montague, the former owner of the painting: "He was a student that then came around the studio and posed for him. I think it was over a series of months. Barkley was pretty meticulous, a slow painter that loved it the way you love fine wine. He would come back to it, you know, day after day or week to week. So it wasn't a one off. The process is long and painstaking."

Figs. 67–70
Photographs by Barkley L. Hendricks of Donald Formey, undated. Courtesy the Estate of Barkley L. Hendricks

The artist photographed the model in his studio against a white backdrop, from front and back.

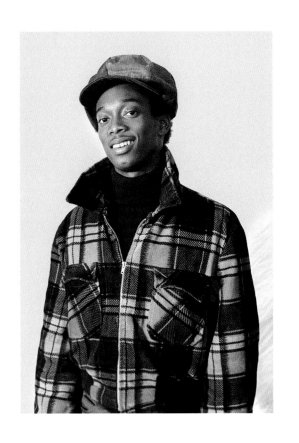
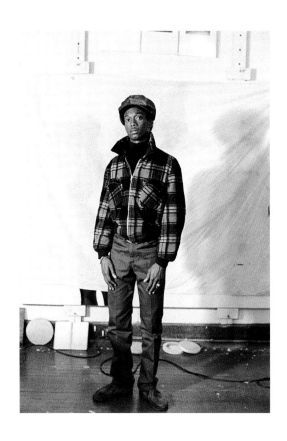
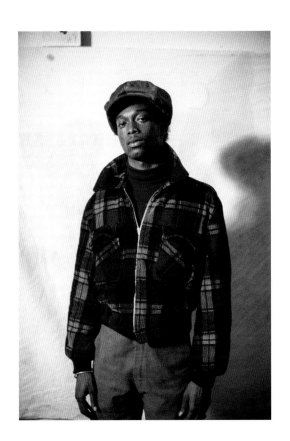
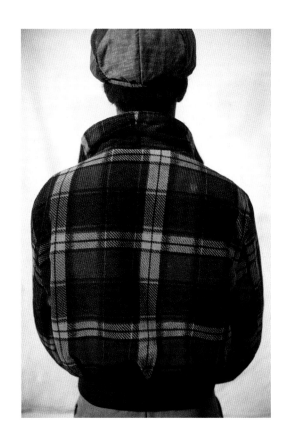

8
NORTHERN LIGHTS

1975.[1] Oil and acrylic on canvas,
72¼ × 72⅛ in. (183.5 × 183.2 cm).
Private collection

NOT IN EXHIBITION

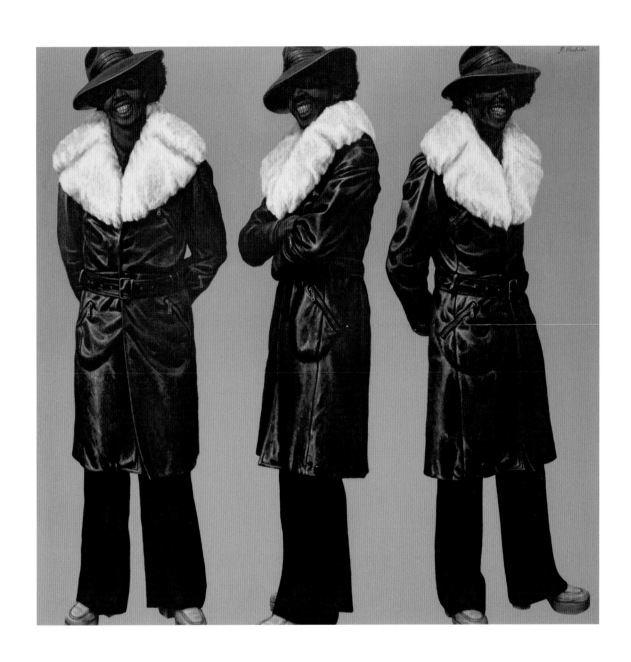

About this painting, Hendricks wrote:

> There was the shine of the green leather coat and the "bling"
> of the gold teeth that inspired the title for the painting of
> the Boston-based brother. He was also in a double portrait
> I called *Yocks* [fig. 75]. *Yock* was the name given to a dude
> who knew how to "rag." Rick Powell would call them
> dandies. . . . Someone once referred to the figure I did in
> the *Northern Lights* painting as a pimp. It was his big hat and
> large fur-collared coat that was behind the assessment. I
> said I once saw Ronald Reagan in the same large fur-collared
> coat. Did that make him a pimp? You'll have to answer that
> one. Sometimes clothes do make the man.[2]

The gold-capped tooth of the grinning model in the painting is
not apparent in the photographs, of which only black-and-white
examples are known. The artist also altered the model's clothing
by replacing the plaid-patterned shirt with a solid red color, and
eliminating the gloves he holds in his hand (fig. 71).

In the photographs, the round sprinkler alarm visible at left on
the exterior brick wall (bearing a sign for a pharmacy) reads
Globe Co./Phila. PA; such alarms were installed in cities outside
of Philadelphia, where the Globe Co. alarm covers were made,
including Boston, where the photographs may have been taken.

Eight sequential photographs of the work in process were pub-
lished in the catalogue accompanying *Birth of the Cool*.[3]

Select exhibitions: New York 1976; New York 1980; Bridgeport
1988; New London 2001; Brunswick 2017.

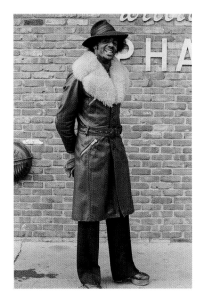

Figs. 71–74
Photographs by Barkley L. Hendricks
of the unidentified model in *Northern
Lights*, ca. 1975. Courtesy the Estate of
Barkley L. Hendricks

The artist photographed the model in
different poses, three of which appear in
Northern Lights, and with a second uni-
dentified model, from which he derived
the double portrait *Yocks*.

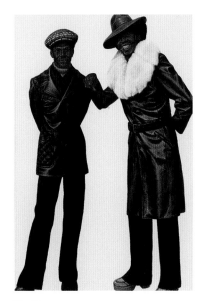

Fig. 75
Barkley L. Hendricks, *Yocks*, 1975. Oil and
acrylic on canvas, 72 × 48 in. (182.9 × 121.9
cm). Private collection

NOTES

1 An archival document related to the painting gives the date
 range: December 13, 1975–March 19, 1976.
2 Durham and other cities 2008–10, 105–7.
3 Durham and other cities 2008–10, 109.

 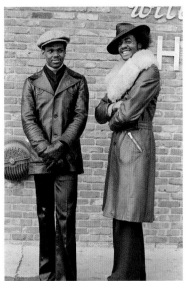 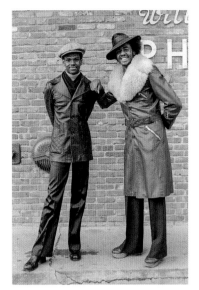

9

MISC. TYRONE
(TYRONE SMITH)

1976.[1] Oil and Magna on canvas,
72 × 50 in. (182.9 × 127 cm).
The George Economou Collection

"I met him on the streets of Philly," Hendricks remembers of the subject, Tyrone Smith. "I just liked the way he looked, so I asked him, 'Can I take a few shots of you?' He went into a whole theatrical posing thing. We're out in the middle of a major downtown area, and he was posing, and it looked like a photo shoot. All of a sudden we had a little crowd, and he was going through his moves. . . . After we were finished, I shook his hand, he went his way, and I went mine."[2]

Chosen from a number of Smith's poses as captured by Hendricks, the final painting composition closely follows one photograph (fig. 78) in which the legs are cropped above the ankles. Hendricks eliminated Smith's triple-chain necklace as well as a polka-dot handkerchief or other accessory hanging presumably from his back pocket, and a small white stick—like that of a lollipop—held in Smith's left hand.

According to archival documents, Hendricks started this painting on August 8, 1976, the same day he began *Steve* (cat. 10), finishing both in less than two months.

Select exhibitions: Roxbury 1980; New York 1980; Hampstead 1983; Durham and other cities 2008–10.

Figs. 76–79
Photographs by Barkley L. Hendricks of Tyrone Smith, ca. 1976. Courtesy the Estate of Barkley L. Hendricks

No color photographs of this impromptu photo shoot are known. Hendricks edited a number of details when translating the figure from photographs to painting, including omitting Smith's necklace, polka-dot handkerchief, and a small white stick held in his right hand.

NOTES

1 An archival document related to the painting gives the date range as August 8, 1976–September 27, 1976, and the title as *Misc. Tyrone* without the model's full name, as it has since often been published.
2 Canavan 2008.

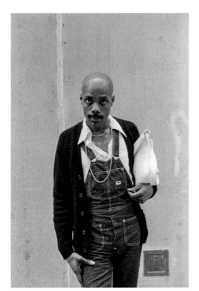 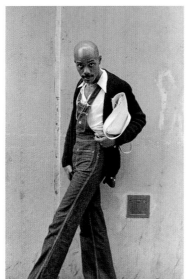 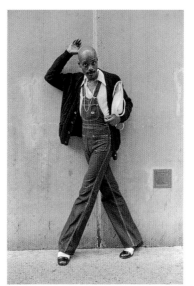

10

STEVE

1976.[1] Magna, acrylic, and oil on linen,
72 × 48 in. (182.9 × 121.9 cm).
Whitney Museum of American Art, New York;
purchase and gift with funds from the Arthur M. Bullowa Bequest
by exchange, the Jack E. Chachkes Endowed Purchase Fund,
and the Wilfred P. and Rose J. Cohen Purchase Fund

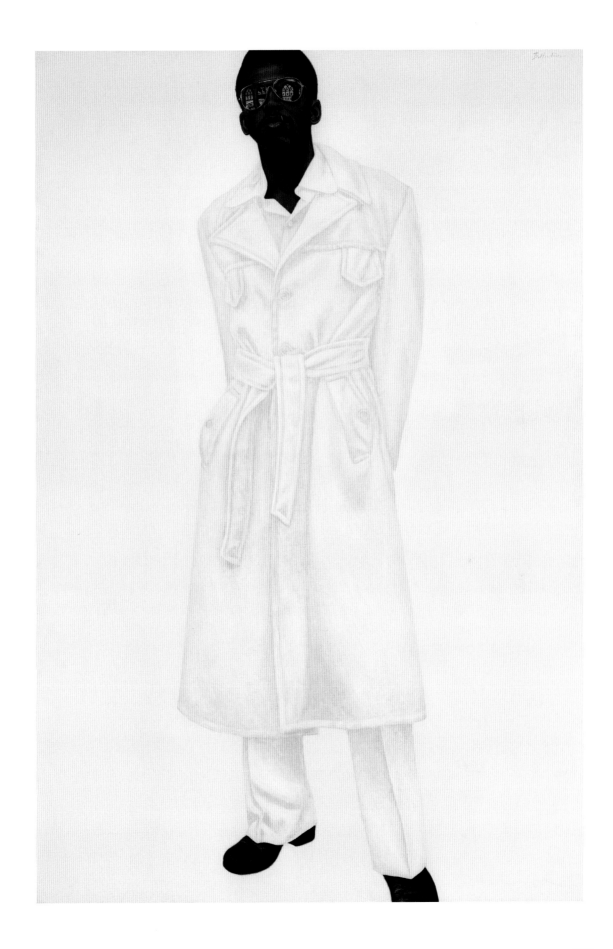

Regarding the materials used in *Steve*, Hendricks wrote "It was a white-on-white piece that was oil, acrylic, and Magna. Magna was a paint that was used that was very workable, close to oil, but it dried faster. Being a synthetic resin material, it wasn't supposed to yellow. Oil, being a paint that was ground with linseed oil or walnut oil, over the years would tend to yellow a bit more than acrylic and Magna. So I wanted to use a double-core Magna for the clothing area."[2]

Taking photographs of the model against a graffiti-marked brick wall at two ranges (figs. 80, 81), Hendricks chose the full-length view for the painting, for which he retained the model's toothpick at his lip but changed the style of the sunglasses, as well as the reflection in them. In the photographs, shapes evoking the flat tops of buildings against the sky are reflected in the lenses of the angular black-framed glasses, while in the painting, aviator-style sunglasses reflect the arched windows of Hendricks's State Street studio in New London, Connecticut, as well as a partial self-portrait at far right (see detail page 136). He also changed the color of the pants to white.

Select exhibitions: New York 1980; Durham and other cities 2008–10; New York 2016–17.

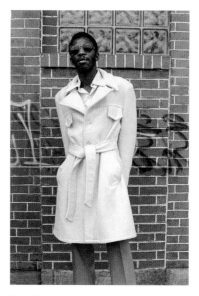

Figs. 80, 81
Photographs by Barkley L. Hendricks of the model for *Steve*, ca. 1976. Courtesy the Estate of Barkley L. Hendricks

Experimenting with the cropping of the figure with these photographs, the artist retained the model's toothpick held at his lip for the painting, but he changed the style of the sunglasses and the reflection in them.

NOTES

1 An archival document related to the painting gives the date range: August 8, 1976–October 7, 1976.

2 Pedro 2016. On the painting's conservation, see also Lerner 2016.

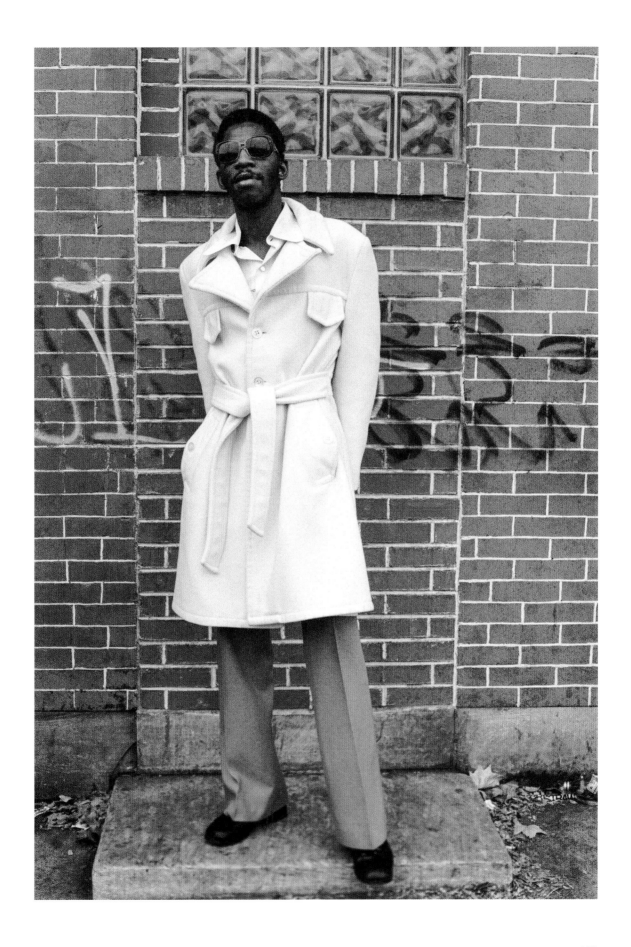

11

SLICK

1977.[1] Magna, acrylic, and oil on canvas,
67 × 48½ in. (170.2 × 123.2 cm).
Chrysler Museum of Art, Norfolk;
Gift of the American Academy
and Institute of Arts and Letters, New York

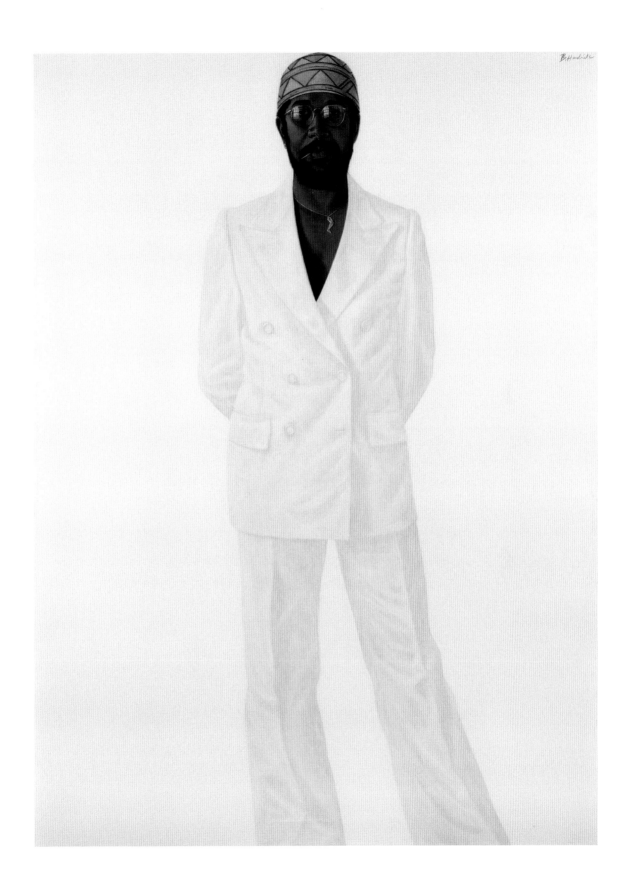

Regarding self-portraiture, the artist wrote: "'Since you are always around' was one of the descriptions I heard to define self-portraiture. I was not fascinated with myself as much as Rembrandt or depressed to the extent of Van Gogh."[2] Discussing his self-portraits, he noted, "I've always liked playing around with hiding eyes and using sunglasses as a fashion statement as well as protecting my eyes, so that became the major prop."[3]

Hendricks described the cap worn in the portrait as from an African design probably of Muslim origin; he had his made in colors while the original design was brown and white, and he included it here to enhance the composition. The necklace, the artist recounted, has no significance other than being the right shape to fit in the V of his coat. It was made in Mexico and a gift from a lady friend.[4]

About the title: "My sister said to me one day, 'You think you're so slick, just wait, one day a woman is going to straighten you out.' Ah, a great title for a painting."[5] Richard J. Powell also notes that the title, like *Brilliantly Endowed*, appropriates words used by *New York Times* critic Hilton Kramer to describe Hendricks's work.[6]

No photographs taken in preparation for the painting are known, though two photographs (figs. 82, 83) show *Slick* side-by-side with another self-portrait, *Brilliantly Endowed*. In both paintings, the artist presents himself with a toothpick at his mouth and a necklace with a leg pendant, which he often wore.

Select exhibitions: Norfolk 1980; New London 1991; Norfolk 2001; Durham and other cities 2008–10; Norfolk 2012.

Fig. 82
Photograph by Barkley L. Hendricks of the artist in his studio standing between two self-portraits, *Brilliantly Endowed* and *Slick*, ca. 1977. Courtesy the Estate of Barkley L. Hendricks

The artist wears socks similar to those in *Brilliantly Endowed*, and most of his necklace—probably the one with the leg pendant pictured in both paintings—is hidden beneath his T-shirt.

Fig. 83
Photograph by Barkley L. Hendricks of *Slick* hanging in the artist's studio amid other self-portraits and *Vendetta*, undated. Courtesy the Estate of Barkley L. Hendricks

On the ground is a projector, which the artist sometimes used to transfer compositions onto large canvases.

NOTES

1 An archival document related to the painting gives the date range: April 4, 1977–June 10, 1977.
2 Durham and other cities 2008–10, 104.
3 Hendricks 2008–10, 67.
4 According to notes from a telephone call between the artist and Nancy Jacobson, dated May 17, 1984; Chrysler Museum of Art curatorial file.
5 Durham and other cities 2008–10, 104.
6 Powell 2008, 154. "A brilliantly endowed painter who erred, perhaps, on the side of slickness"; Kramer 1977.

AIMEE NG

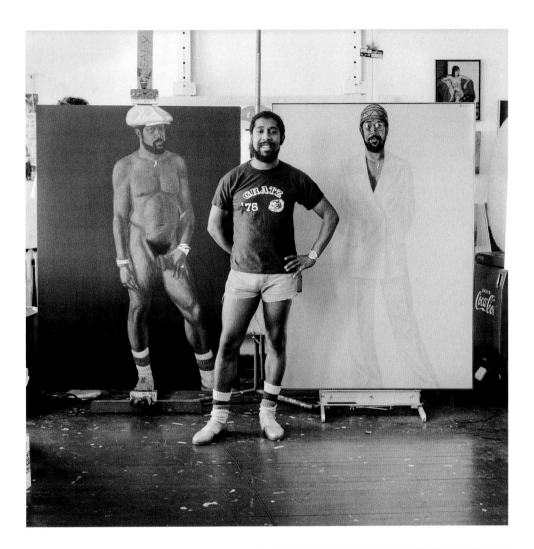

12
SISTERS
(SUSAN AND TONI)

1977.[1] Oil and acrylic on canvas,
66 × 48 in. (167.6 × 121.9 cm).
Virginia Museum of Fine Arts, Richmond;
Funds contributed by Mary and Donald Shockey, Jr.

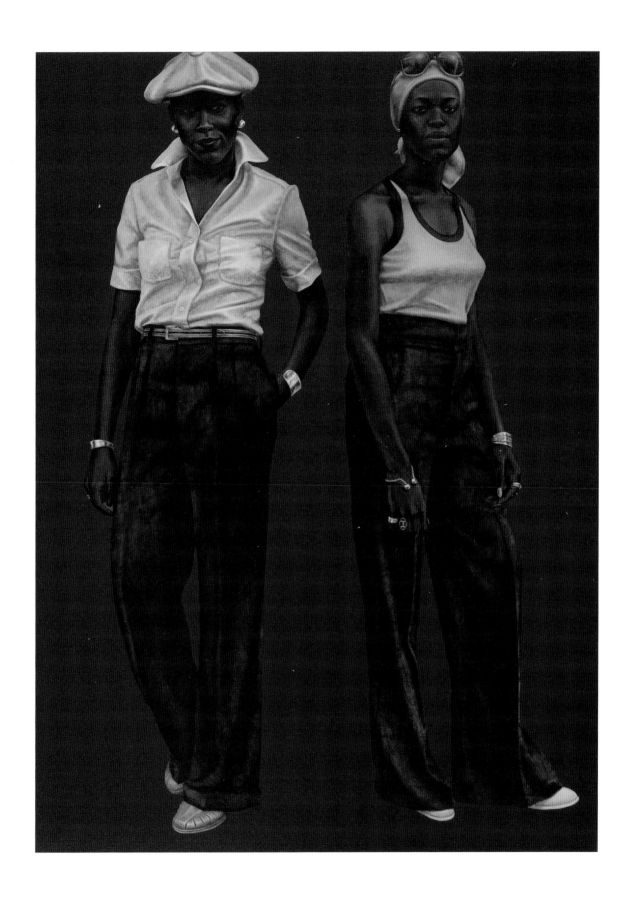

The artist met the women pictured here in Boston.[2] Experimenting with their poses and relationship to each other in photographs, he selected a composition for his painting in which their bodies do not overlap. As was his usual practice, he edited out details such as the necklaces worn around their necks, but he conveyed with exactitude their bracelets and rings. He altered the pattern of the head scarf of the woman on the right to a solid green color in the painting, which he also painted as a reflection in the spherical earring of the woman on the left (see detail of earring page 2).

Hendricks applied varnish with particular precision throughout the composition, setting off the figures from the background, including on details such as the belt loop of the figure on the left. He appears to have signed the canvas in varnish at upper right.

Select exhibitions: Fairfield 1978; New York 1980; Durham and other cities 2008–10.

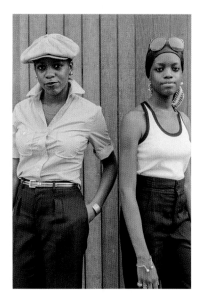

Figs. 84, 85
Photographs by Barkley L. Hendricks of the models for *Sisters (Susan and Toni)*, undated. Courtesy the Estate of Barkley L. Hendricks

The artist edited out the women's necklaces but painted precisely their intricate bracelets and rings.

NOTES

1 An archival document related to the painting gives the date range: July 28, 1977–October 27, 1977.
2 According to the acquisition report by John B. Ravenal, dated May 2010; Virginia Museum of Fine Arts curatorial file.

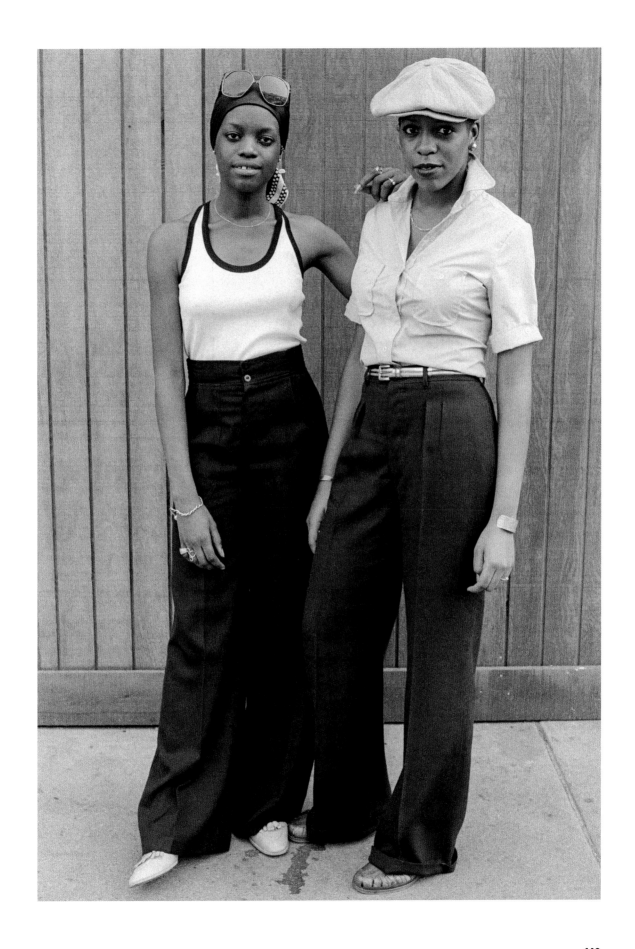

13

APB'S
(AFRO-PARISIAN BROTHERS)

1978.[1] Oil and acrylic on canvas,
72 × 50 in. (182.9 × 127 cm).
Yale University Art Gallery, New Haven;
Janet and Simeon Braguin Fund

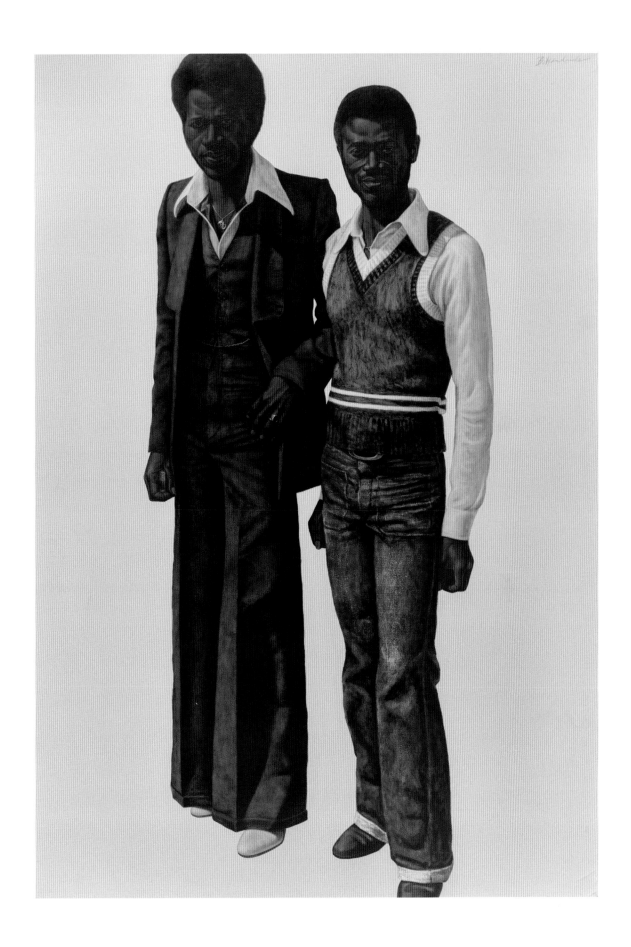

The artist recalls walking through the Parisian neighborhood of Pigalle, where he noticed well-dressed Black men and women. He was particularly taken by two gentlemen.[2] Remembering his encounter with them, the artist remarked: "There was a style at the time with the long, slit-back suits that you saw a lot of tall, graceful African brothers wearing, and these gentlemen were gracious enough to allow me to photograph them. Once I got back, I did a couple of paintings from them or at least one piece with one guy [fig. 86] and then another painting with both of them [*APB's (Afro-Parisian Brothers)*]."[3]

A photograph of the two walking in the street (fig. 89)—complete with a cyclist blurring by and partially obscuring the figure on the right—captures the men in motion in an urban context, while two photographs (figs. 87, 88) present the models posing in the ways they would appear in Hendricks's paintings.

In *Noir*, Hendricks faithfully recorded the pink-and-gray pinstripe pattern of the subject's fitted suit in a process so laborious that in his reprisal of the figure in *APB's (Afro-Parisian Brothers)* he did not duplicate the effect, concentrating instead on the intricate folds of the figure's suit and on the variety of textures worn by both.[4] Though in the photograph the model for the figure on the left is pictured carrying objects in his right hand—a cigarette and cigarette pack and probably a bunch of keys—for the paintings, Hendricks included only the pack of cigarettes; he also added a slender chain across the man's waistcoat. The other model can be seen carrying a coat and umbrella in the walking photograph.

On jeans (fig. 90):

> You see a lot of people paint jeans. But no one paints jeans like me, with the consciousness of the fact that jeans are a material that is worn rather than painted. When I say "worn" I mean the way denim actually looks—you can see the fabric that has been worn down, especially now that they're selling you material with gaping holes. . . . The art of painting is not only about putting paint down. I like to use the texture of the canvas as a vehicle to get the illusion that I'm interested in.[5]

Select exhibitions: New York 1980; Bridgeport 1988; New York 2005; Durham and other cities 2008–10.

NOTES

1 An archival document related to the painting gives the date
 range: January 4, 1978–April 20, 1978.
2 Arabindan-Kesson 2016, 73.
3 Hendricks 2008–10, 63.
4 In conversation with Susan Hendricks, 2022.
5 Pedro 2016.

Fig. 86
Barkley L. Hendricks, *Noir*, 1978. Oil and acrylic on canvas, 72 × 48 in. (182.9 × 121.9 cm). Rubell Museum, Miami

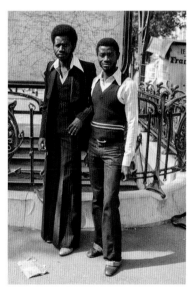

Figs. 87, 88
Photographs by Barkley L. Hendricks of the unidentified models for *APB's (Afro-Parisian Brothers)*, undated. Courtesy the Estate of Barkley L. Hendricks

The models pose in front of an Art Nouveau–style entrance to the Paris Metro, with a map of the city's transit system behind them. In the photograph of the single model, the hand of the second model can be seen resting on the iron railing, indicating that he was waiting out of the camera's field of view while Hendricks photographed his companion.

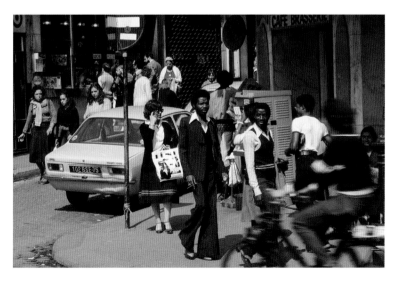

Fig. 89
Photograph by Barkley L. Hendricks of the unidentified models for *APB's (Afro-Parisian Brothers)*, undated. Courtesy the Estate of Barkley L. Hendricks

The artist photographed the subjects walking in the streets of Paris. Items such as the cigarette carried by the man on the left and the coat and umbrella carried by the man on the right were omitted by Hendricks from the paintings, while he added a slender chain to the waistcoat of the man in the suit.

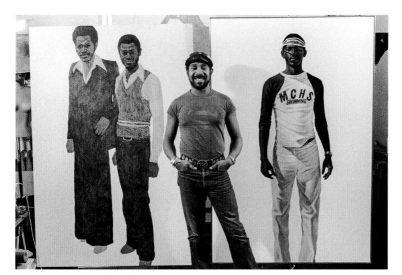

Fig. 91
Photograph by Barkley L. Hendricks of the artist in his studio standing between the unfinished *APB's (Afro-Parisian Brothers)* and *Tuff Tony*, ca. 1978. Courtesy the Estate of Barkley L. Hendricks

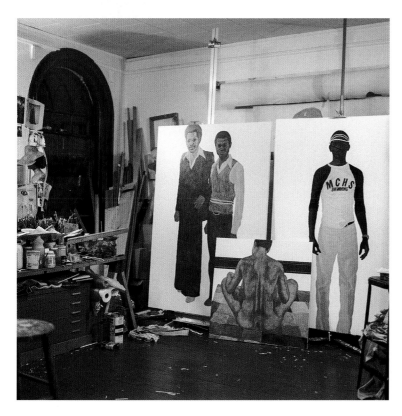

Fig. 92
Photograph by Barkley L. Hendricks of his State Street studio in New London, Connecticut, at night, ca. 1978. Courtesy the Estate of Barkley L. Hendricks

Visible are the arched windows often included in reflections in his portraits, the unfinished *APB's (Afro-Parisian Brothers)*, *Tuff Tony*, and *Untitled (Adrienne)*, a painting of a seated nude depicted from behind.

Fig. 90
Detail of cat. 13

14

LAGOS LADIES
(GBEMI, BISI, NIKI, CHRISTY)

1978.[1] Oil, acrylic, and Magna on canvas,
72 × 60 in. (182.9 × 152.4 cm).
Private collection

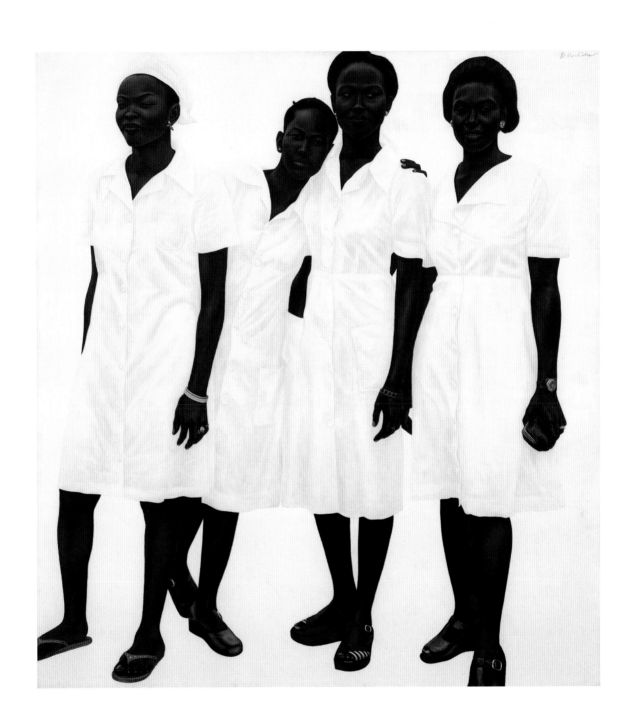

These women were cooks at one of the hotels for visitors to FESTAC (Second World Black and African Festival of Arts and Culture) in Lagos, Nigeria, which the artist attended in 1977.[2]

In the photographs taken outdoors in a sandy terrain, in front of a number of buildings, the artist experimented with posing the women—capturing them in both color and black-and-white—and paid attention to their footwear, which he augmented slightly in the resulting painting. Three of the women wear necklaces in the photographs that Hendricks did not include in the painting, though he did retain their bracelets and earrings.

NOTES

1 An archival document related to the painting gives the date
 range: July 17, 1977–January 23, 1978.
2 Powell 2008, 158.

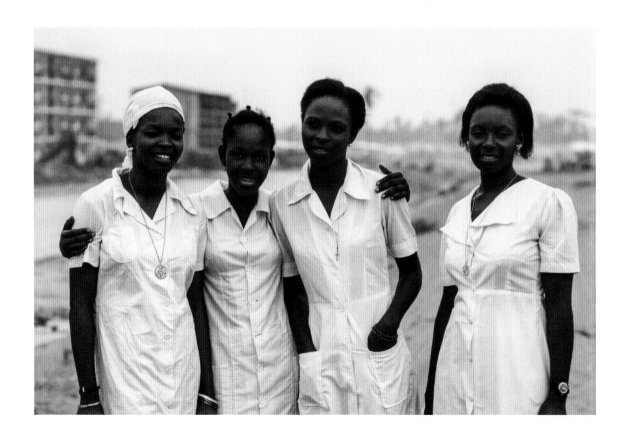

Figs. 93–96
Photographs by Barkley L. Hendricks of
the subjects of *Lagos Ladies (Gbemi, Bisi,
Niki, Christy)*, 1977. Courtesy the Estate of
Barkley L. Hendricks

The women, cooks at a hotel hosting
visitors to FESTAC '77, pose for the
artist outdoors in various configurations.
Hendricks studies their footwear in
one photograph.

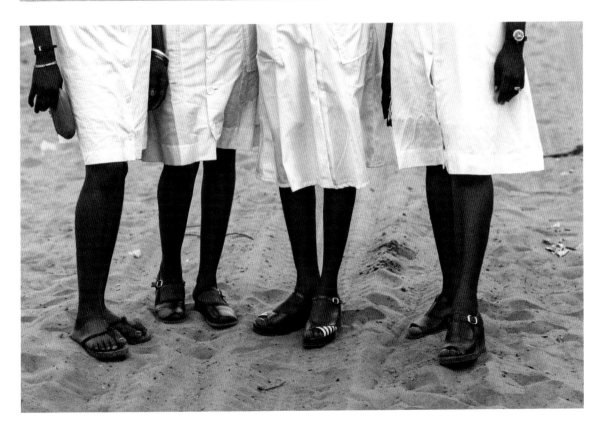

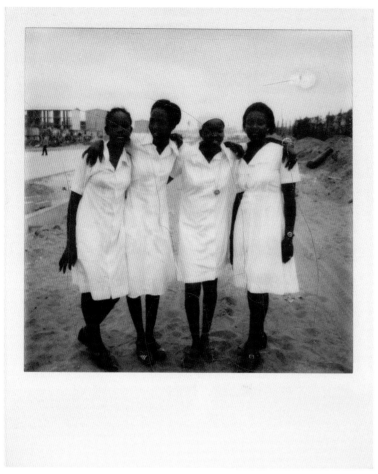

Fig. 97
Polaroid photograph by Barkley L.
Hendricks of the subjects of *Lagos Ladies
(Gbemi, Bisi, Niki, Christy)*, 1977. Courtesy
the Estate of Barkley L. Hendricks

Fig. 98
Photograph by Barkley L. Hendricks of the
artist with unfinished paintings *Hasty Tasty*
(see fig. 33) and *Lagos Ladies*, ca. 1977.
Courtesy the Estate of Barkley L. Hendricks

The self-portrait with paintings in progress
shows *Lagos Ladies* in a state in which the
figures are blocked in like silhouettes.

15

OMARR

1981.[1] Oil and acrylic on canvas,
48 × 47¾ in. (121.9 × 123.8 cm).
Courtesy Barkley L. Hendricks Estate and
Jack Shainman Gallery, New York

Omarr is one of three known single-figure portraits by the artist depicting the subject from behind, the others being *Vitamin K for Fun* (Menil Collection, Houston) and *Untitled (Adrienne)* (Jack Shainman Gallery). *Omarr* is the only one in the limited-palette series. The sitter wears two sets of sunglasses, a single earring in the left ear, and a pinky ring on his right hand. What appears to be a red mitten, from which hangs a snap hook, is worn on the left hand (fig. 99).

No photographs of the model taken in preparation for the painting are known.

Select exhibitions: Hartford 1983.

NOTE

1 An archival document related to the painting gives the date
 range: January 30, 1981–July 9, 1981.

Fig. 99
Detail of cat. 15

16

MA PETITE KUMQUAT

1983.[1] Oil, acrylic, white gold,
and silver leaf on canvas,
72 × 40 in. (182.9 × 101.6 cm).
Collection Ben and Jen Silverman

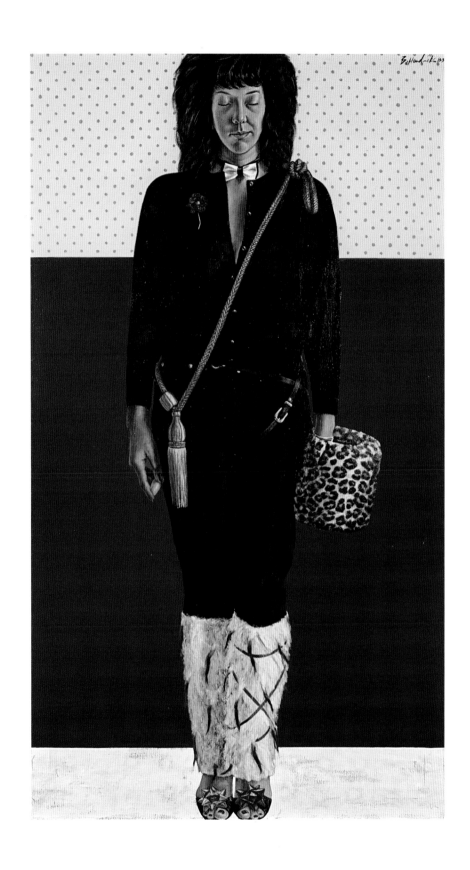

The subject is the artist's wife, Susan Hendricks. An article of May 1, 1983—about a month after their marriage—in *The Day* of New London, reports that Hendricks painted the portrait over several years, adding new details periodically.[2] This is the last portrait the artist made until 2002. In the interim, he devoted himself to exploring other genres, especially landscapes in watercolor and oils.

Hendricks's archives include a preparatory drawing, relatively rare in his portraiture practice (figs. 106, 107).[3] It provides insight into Hendricks's invention of a portrait composition on paper before he began the painting itself, for which he relied on photographs and study of the live model. Hendricks drew it in about 1980, on a notepad belonging to Susan (printed with a series of mouths at the top and, on the bottom, "Design by Charles White III"); the fold at the top represents the artist experimenting with the cropping of the figure at the top edge, which corresponds to the painting.

After he made the sketch, he took photographs of Susan from the front and back, and details of her footwear. In the painting, Hendricks removed her glasses, changed the color of the nail polish on her hands and feet, and added various accessories, including a bow tie, leg warmers, a green cord with tassel, and gift-wrapping bows on the tops of the shoes.

Hendricks found the leopard-skin muff (held in the figure's left hand) at a Salvation Army thrift store.[4] Later, he wrote that his friend Anderson Williams (the subject of his portrait *Andy* [private collection]) gave him a kumquat, "some little orange fruit I had only heard about in jokes." At the time, "I was working on the portrait of Susan, and I needed an additional warm color. So that little piece of citrus, which necessitated an acquired taste attraction, gave the painting just what it needed as well as its name: *Ma Petite Kumquat*."[5]

In a 2008 video interview made at the time of the *Birth of the Cool* exhibition, Susan describes the experience of posing for the artist: "You'd be amazed how hard it is to stand in high heels with your eyes closed."[6]

Select exhibitions: New Haven 1985; New London 2001; Durham and other cities 2008–10; New London 2011.

Figs. 100–105
Photographs by Barkley L. Hendricks of Susan Hendricks, ca. 1981. Courtesy the Estate of Barkley L. Hendricks

Hendricks studied the model—his wife, Susan—in various poses and with attention to her footwear.

NOTES

1 An archival document related to the painting gives the date range: February 5, 1980–January 28, 1983.
2 Murphy 1983.
3 In conversation with Susan Hendricks, 2022.
4 Murphy 1983.
5 Durham and other cities 2008–10, 98.
6 Nasher video, 2008.

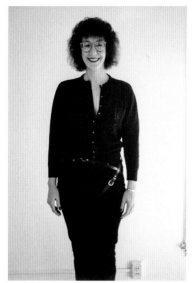
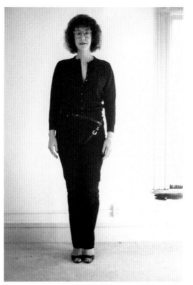

Design by Charles White III

Figs. 106, 107
Barkley L. Hendricks, sketch for *Ma Petite Kumquat*, ca. 1980. Pen on paper, unfolded: $8^{5}/_{16}$ × $5^{5}/_{16}$ in. (21 × 13.5 cm); folded: $7^{1}/_{8}$ × $5^{5}/_{16}$ in. (18 × 13.5 cm). Courtesy the Estate of Barkley L. Hendricks

A rare example of a drawing made in preparation for a portrait, the sketch captures generally what would become the final composition for the painting, including the cropping at the top.

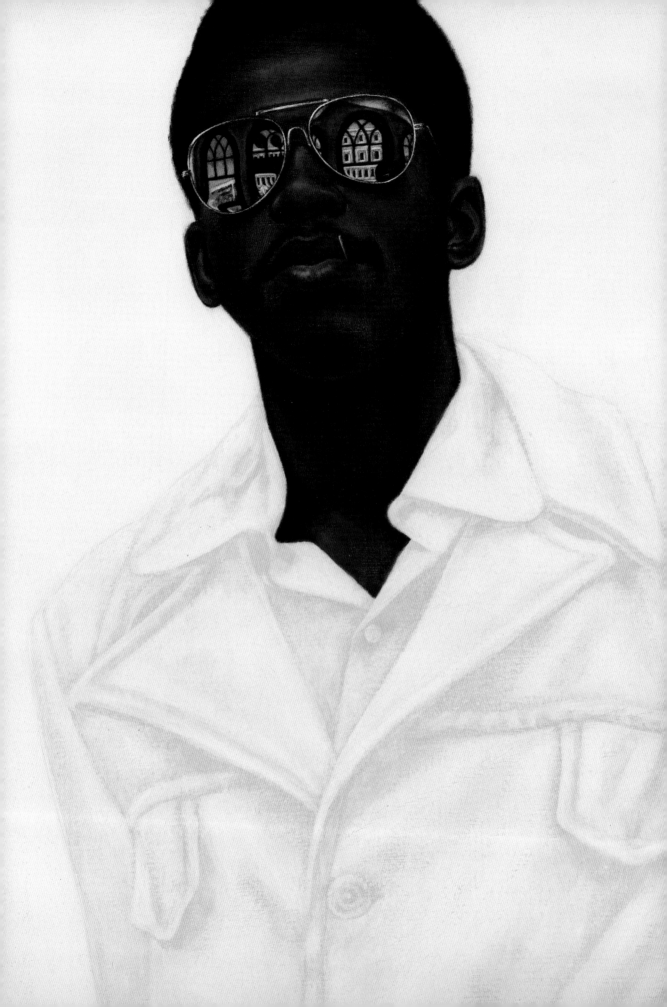

Reflections

Derrick Adams

COMING THROUGH

Barkley's work is a blueprint for the reductive quality of representation. In earlier paintings of this genre by that generation of artists—and even now—there's an element of compensation in representing the Black figure. In order to give the figure credibility or significance, the artist sometimes feels it's necessary to add surrounding details. Barkley was able to confer that significance without those elements of decor and still talk about class and fashion and style. It's a very clever way to highlight the subject—the Black figure and the Black body—without detracting from it. It speaks to how the Black figure can hold its own without an elaborate background and how the Black figure can be an atmosphere as well. Through Barkley's unique execution, the Black figure is at a level of exaltation that was not there before, and this has liberated my practice. I've included backgrounds and spatial construction with my images, but I've understood them in a very different way because of the way that Barkley handled space and composition and the reduction of environment around the figure.

Barkley started to create a dialogue around thinking about the figure in the abstract, and that's what I took away from studying his work. His technique—where the figures are very detailed, very polished—became a unique way of communicating. Basically, the figure could be in any urban space, in any city. There are no markers that situate the figure in Harlem or in Philadelphia or in Baltimore. His figures represent this universal world. When I look at them, I understand how important they are but also how familiar they are and how much they mirror people in other cities. Barkley's mirroring gives Black people a sense of empowerment: they see themselves reflected in these surfaces without a lot of other things that distract. And I'm

interested in that too because the simplification of the things I make is meant to heighten a certain level of complication when looking at the Black figure and the Black figure being a sculptural thing, a sculptural object. I'm interested in talking about that as it relates to some of the traditions of African sculpture and wood sculpture and wood carving.

The funniest thing is that, about five years ago, I made a portrait of a woman with mirrored sunglasses, with a head wrap; it's a collage, but the gaze of the figure was obscured by these lenses. Recently, someone posted an image of a painting, a woman with a head wrap and round mirrored glasses, and when I first saw it I was like, who made this? I realized it was Barkley, made in the early '70s, around the time I was born. It really blew me away because, so many years later—I made my piece in 2015—I saw his and I'm like, oh shit, I'm not that new!

The construction of Hendricks's work and his use of color-blocking or layering or the reduction of the background relates to how I make work because I incorporate color-blocking on the figure. I do this also to show that the figure is both the environment and the subject. Barkley does it in another way because he says the figure is the subject and the background is like the platform for the figure. I work in a similar abstract way where I'm showing the figure and the environment as one, and they can appear to be the same from a particular level of composition. For me, the philosophy of that is that Black people actually create space; they're not separate from it. So when I'm painting the facets of the space around the figure, it can be angular or reduced to a shape, a geometric form—it's trying to have a conversation about the architectural framework around the figure and the environment and how those things are not necessarily separated from each other, maybe by color but not by form.

As told to Antwaun Sargent

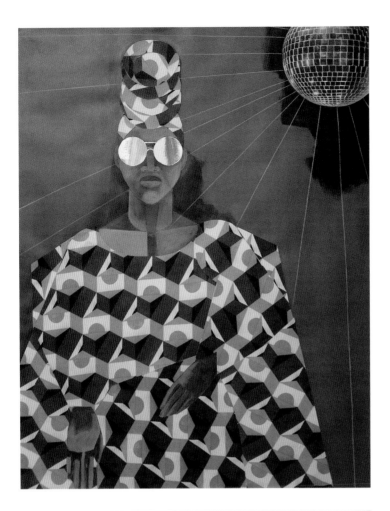

Derrick Adams, *Coming Through*, 2015.
Mixed media on paper, 42 × 34 in. (107.7 ×
86.4 cm). Courtesy the artist

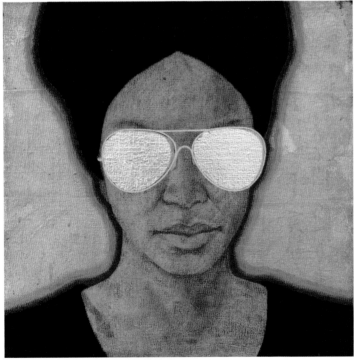

Barkley L. Hendricks, *Estelle*, 1972.
Oil, acrylic, and dayglo paint on canvas,
12¹/₁₆ × 12¹/₁₆ in. (30.6 × 30.6 cm).
Private Collection

Hilton Als

THE GENTLEMAN

It was Thelma Golden who introduced me to Barkley Hendricks's work. That would be in 1994, when Thelma was working on *Black Male: Representations of Masculinity in Contemporary American Art* at the Whitney. It was glorious to watch her work. Not only was she showing artists who would go on to change the face of the New York cultural scene, she was creating an ethos in which those artists had to be seen. The art world in general and the art market in particular were about to change substantially because of her vision and her belief that the largely white art universe had to be, and could be, integrated. Were we not living in the real world together? And wasn't art supposed to reflect that? I was there while Thelma installed the exhibition—she worked very quickly—and if I close my eyes, I can see one of the Hendricks works she showed, a vertical painting that made me feel as though I was looking at life. Because I was. Whether Hendricks was working from a model or his imagination, his work had the verve you associate with the energy of youth and persons who insist on declaring their presence. I think *monumental* is an overused word, so I won't use it here. Let's replace it with *tremendous*. That's what I first thought when I saw Hendricks's paintings—that they were tremendous not only in scope but in execution. His lines were razor sharp but full of feeling for an about-to-pivot leg, a trouser hem, a stance. What I especially loved was that his subjects looked at me. They were there, present, ready not only to be engaged but to be in conversation with the viewer. They are deeply generous paintings that way and generous, too, in that they make graphic sense. Barkley wants us to see his subjects whole, and part of the joy of painting for him, I would imagine, was how best to do that without sacrificing complexity on the canvas.

You can look at Hendricks's love of costuming and think of this gentleman's hat or the collar on that gentleman's coat as abstractions since his subjects' apparel often plays with, meets, and parts with the white space around them. But I think that Hendricks, like other great portraitists of the age, such as Alice Neel, was first and foremost interested in the psychology of his subjects and how and why bodies want to take up space in a painting, in life, in the imagination. Looking at Hendricks's work for the first time that afternoon long ago with Thelma, I thought of the great American poet Gwendolyn Brooks, who, like Hendricks, was involved for most of her creative life with trying to build a universe in which a person's race was a given, not a sociological construct but a part of their being, their blood. Indeed, when I think of epic poems by Brooks—*Annie Allen* (1949) and especially *In the Mecca* (1968)—I think of Hendricks, especially when it comes to the specificity of his subjects' bodies and his commitment to rendering their inner lives and dreams as forcefully and softly as the reality one finds, or can find, in poetry that matters.

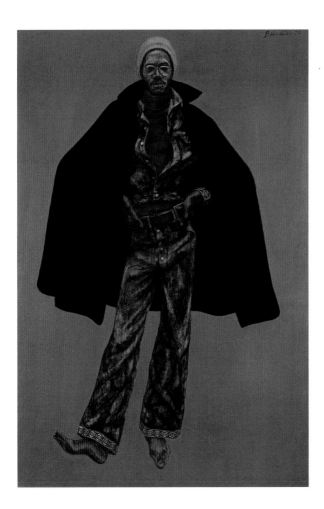

Barkley L. Hendricks, *George Jules Taylor*, 1972. Oil on canvas, 91⁷⁄₁₆ × 60¼ in. (232.3 × 153 cm). National Gallery of Art, Washington; William C. Whitney Foundation

Hilton Als, *Sherry Vine and Joey Arias, Performers, New York, December 16, 2018.* Polaroid photograph. Courtesy the artist

Nick Cave

SUPER FLY

When I saw Barkley Hendricks's painting *Steve* (cat. 10) in the exhibition *Color*, it was the first time I'd ever seen a Black male figure depicted in this way. I'm just thinking like super fly—Black power, expression. It was profound for me to see that we could paint ourselves in this proud way. You know, back in the early '70s, there were no Black artists in exhibitions. You just didn't see them. Seeing *Steve* changed my life, helped me see the importance of style, of a style we could own. With everything that was stripped away from us as we were growing up, we still found a way to have style. Barkley's white-on-white work was about style, about standing in the light and being seen—that idea of being seen, yet not allowed to be seen. That juxtaposition was quite beautiful.

We have the right to stand in that white-on-white space of pride and purity and power, and that also connects to religion. I could definitely see that in church, as I watched my grandmother. She was very involved in the church, and they all had to wear white. Barkley really set the stage for a lot of artists coming up—particularly in his figurative work.

Barkley helped me realize that I have a platform. He, and some others who came before me, gave me permission to stand in my truth. When I think about *Steve*, I think about standing in my truth. For me, that means thinking about color and adornment and ways of celebrating the body, celebrating the craft, thinking about the early Black craft movements that have been pivotal in my practice, thinking about how we elevate the fundamentals of that and create this new renaissance.

When I was about twelve, I went to Chicago to stay with my uncle for the summer. At one point, we went to a flea market, and as we were walking around, we saw a guy open his trench coat and inside all was hanging. That revealing and concealing was sort of a moment of magic for me. That's why I made *Hustle Coat*. There was this period of filmmaking when there was a certain style that conferred a particular sort of status in the hierarchy. But, at the same time, that style created a facade. You know, standing stout and proud and with shoulders pushed back, you could have nothing and still look fabulous. I could see *Steve* next to one of my *Soundsuits*—they share this projection of status and feeling larger than life and the posturing and posing. And that in turn relates to how clothes affect us and how we make an entrance.

When I think about *Steve*, I think about *Soul Train* and dress as peacocking, displaying your feathers, showing everything and showing nothing. I think about the fact that his work, my work, covered up; yet it feels very vulnerable at the same time. It's breaking those stereotypical notions of how we've been seen.

Ultimately, it's about controlling the conversation. You're not going to place on me a description of what you think I should be, you're going to accept what I've presented, what I've given, what I've illustrated. I'm taking full responsibility, taking charge of that moment, stepping into that space of accountability and ownership of oneself in that moment. I have this painting of Barkley's—*Ruby, My Dear*—that's of a topless pregnant female. She's wearing cowboy boots, leggings, and suspenders, and she's blowing a bubble. She's like, "I dare you to say something." Just the attitude, you know, not only her attitude but the painter's attitude. I think that attitude is equivalent to commitment and responsibility and creating space as a painter, as an artist, as myself. He created a wedge, a space that didn't exist, and that is an attitude of sorts.

I think the legacy of Barkley Hendricks is showing us as seen and empowered and valued. It was Barkley first; then came the others. Barkley created this wedge, this sort of new beginning, this new read.

As told to Antwaun Sargent

Nick Cave, *Hustle Coat*, 2017. Trench coat, cast bronze hand, metal, costume jewelry, watches, and chains, 59 × 41 × 16 in. (149.9 × 104.1 × 40.6 cm). Courtesy the artist

Awol Erizku

ESSENCE OF COOL

My camera, I call my mechanical sketchbook. I'm fast, but I'm not as fast as the camera.

—BARKLEY HENDRICKS

Barkley Hendricks's vivid, life-size, hyper-stylized portraits of Black figures permeate the contemporary fashion consciousness more than the work of any other figurative painter who comes to mind. Classical in their rendering and scrupulous in their detail, the paintings depict the charismatic, majestic, self-assured, and statuesque nature of their subjects. Hendricks's relentless interest in his subjects' physicality and his vigorous attempt to insert Black existence into the stark white canon of Western art history have given many artists who came after him permission to explore and push Black portraiture to new heights. No other artist has done more to capture and ingrain the essence of "cool." With their minimal, bold, and vibrant color palette, his paintings are seductively low-hanging fruit for mood-board harvesters.

My earliest memory of Hendricks is of accidentally stumbling upon his now iconic, pre-social media self-portrait fit-pic from 1980 on Tumblr. In it, he stands posed in front of his mirror, like a cowboy in a western. He's in blue jeans and a red V-neck sweater, and he sports a consumer-grade visor reminiscent of *Star Trek's* Lieutenant Commander Geordi La Forge, shooting a 35 mm film camera in place of the usual Smith & Wesson Model 3 revolver. It didn't dawn on me who this unique individual was until several years later. I would encounter the portrait once again in the *Birth of the Cool* exhibition, at the Studio Museum in Harlem, where it was undoubtedly clear to me the artist and the work were reflections of each other. Though I never

formally met Hendricks, I remember seeing him during his time at the Yale painting MFA critiques in 2014. Authentic and lively as his portraits, he was tall and smooth and moved with a swagger I can only attribute to his work. He was a living, breathing manifestation of the figures in his paintings.

I point to this particular image not only for the purposes of nostalgic reflection but also for its ability to fossilize Hendricks's skin in the game as it pertains to fashion, the creation of self-mythology, and his clairvoyance—and to show that color has been a creative tool in his arsenal throughout his practice. In other words, "He's not new to this, he's true to this." I have an intrinsic appreciation for this portrait as it validates an urge I have to grab my camera and stand in front of a good reflective surface when I put on some fly shit.

In Hendricks's *What's Going On* (see fig. 39), one of my favorite works, five stylish figures occupy more than two-thirds of the canvas, edge to edge like an unfolding accordion. Their gazes go in two directions, and three figures seem to be preoccupied with what's taking place to the right of them—all while a statuesque female figure in the center stands in front of a man wearing a wide-brimmed fedora. They all look toward the viewer. Though all the figures, with the exception of the nude female on the left, are dressed in fine threads, Barkley has managed to preserve the mystery, beauty, and pure essence of the nude woman. As mastery of simplicity and directness in both painting and picture making, this composition lives rent-free in my head for all eternity.

For a recent *GQ* magazine commission for *When They See Us*—a 2019 Netflix miniseries created, co-written, and directed by Ava DuVernay—I was asked to make images of the five actors with Ava for an issue ahead of the premier of the show. As global visuals director Roxanne Behr and fashion director Mobolaji Olujimi Dawodu—both frequent collaborators of mine—started the conversation about what kind of images to create, I kept circling back to Barkley's *What's Going On*, as it treats with equal importance style and the uniqueness of each individual present in the composition, a deeper layer beneath the fashion that we could use to enhance the visibility of these men and the story

Ava was aiming to tell. We were all fixated on communicating the innocence of these Black and Hispanic men who were wrongly convicted of a crime at such a young age, which changed their lives forever. Given the many connotations implicated by the color white, we figured we could lean on the fact that most readers would take this to mean innocence and demonstrate the humility of these men as portrayed by the actors in the series.

The fashion, as always, was on point, the all-white attire of the men from designers such as Issey Miyake, Dries Van Noten, Dior, and Maison Kitsuné, while Ava was draped in an elegant dark salmon Carolina Herrera dress. We reflected back on this painting throughout the day to use it as a spiritual guide for the actors' movement and direction without re-creating the painting verbatim. The *Soul of a Nation* exhibition was up at the Broad in Los Angeles, where we made the images, so perhaps it was in the air and seemed

suitable and fresh in the minds of some of us to make those distant associations as a way to pay homage to a master, while simultaneously revisiting another familiar story not so distant from recent history.

As an image maker, one of the many aspects I appreciate about Barkley's practice is his ability to translate a photographic image into something ethereal and sublime. With their minimal nature, his portraits gain more than they seem to have lost during the transferring process. His colors seem to illustrate emotions that heighten the exchange between the subject and the viewer in ways that only a master who knows how images function and who can manipulate them can. In the case of Hendricks, I would argue there's nothing more the camera can offer that he can't paint with his mind's eye. A collection of memories and information is but a building block for a ventriloquist with a paintbrush.

Photographs by Awol Erizku of Ava DuVernay and the cast of *When They See Us*. Courtesy Awol Erizku

Rashid Johnson

HOMAGES

I came across Barkley as an artist fairly early on, when I was twenty-one. His work was so bold—I was just blown away by its complexity and its being so in your face and at the same time so direct and simple. I first saw it in Richard Powell's book on African American art. That book was a bible for me. Many of the artists in it weren't well represented at the institutions I was attending to learn about canonical histories; so that book became a kind of canonical vehicle for me. I was like, "No, these guys all matter!" When I saw Barkley's work in the book, I wanted to find out about his project. It just felt so radical to me—of course much less so today because of the kind of embrace of the Black body and figuration that's occurred. But at that time, there were very few examples of Black bodies living in well-considered oiled rectangular spaces—with the exception of old Joshua Johnson paintings and, of course, the work of Kerry James Marshall, who I'm sure was aware of Barkley. It felt so unexpected, so ambitious, and also sincere in a way that really resonated with me. I fell in love with what it was he did. And at that point, I hadn't yet seen any of his work in person, only in reproductions.

As an homage, I made a photograph of myself that borrowed from an image of a painting Barkley had made. I wrote to him to ask for permission but didn't get a response until three years later! He wrote to say, "Oh I loved your photograph, absolutely, I'm so happy you made it."

For me, and I imagine for Barkley as well, being able to frame the discourse was essential—to look at our bodies and push back against some of the themes that had been applied to Black personhood and Black bodies and the idea that those bodies were exclusively poetic or exclusively physical and didn't have intellectual resonance. We could then say, "No,

these are our bodies." Before Barkley's work, most of the images of Black bodies I'd seen were ethnographic images in *National Geographic* or civil rights images or the problematic images of the Black body subjected to white violence, being chased by dogs, sprayed by hoses, the antebellum images of lynching. You think of Mamie Till's astute and ambitious gesture of showing her son Emmett's body in the open casket.

My thinking about the self-portrait, and I imagine this was true for Barkley as well, was that it was an opportunity to say "No, this is us. This is me, and this is me in my intellectual self." This is something a lot of my earlier images made reference to, whether it was imitating Frederick Douglass, creating fictional societies of the Black critical thinkers shown in my photographs, or homages to other historical moments and images, like how I reference Barkley. It was about taking ownership.

Barkley's work flew in the face of Black respectability in a way that was so brilliant, so self-assured and effective. The work never centered Western critical concerns. For me, that was like, "Okay I see this, I understand that we can be in the center of our own conversations and that our work doesn't need to become an illustration of our humanity." That allows white folks to feel comfortable in the fact that we are human or that we are in so many respects just like them. Barkley did not pander to that space, a space I was interested in rejecting. I was more interested in not framing white Western sensibilities as the central position from which to interpret my work.

Barkley was not on the tip of a lot of folks' tongues when I made that self-portrait. For me to title it as an homage to him was an opportunity not only to reflect but to amplify both my own work and that of heroes of mine whom folks were less familiar with. It was about putting myself in a story and making sure it was understood that I was neither the first nor the only artist in this space, framing this discourse that was changing the way we imagine Black bodies and space, respectability issues, and so on. There were important antecedents; I was not alone in wanting to amplify histories. One thing a lot of Black artists have learned over the past fifteen or twenty years is that we build power as a group as opposed to being ushered in singularly, as

some previous generations were forced to. Part of my ambition as an artist is to help build a coalition so that people understand that this has historical resonance, not independent individual storytelling, at its core.

There is so much to unpack around how effective Barkley has been in changing the way we've understood picture making over the last twenty years. The impact his work has had on where and how Black artists produce images is really mind-blowing, truly mind-blowing. There are so many artists whose voices we value who took their cue from Barkley. And if they didn't take their cue from Barkley, it was from people who took their cue from Barkley. You simply cannot separate the embrace of work by African American and African artists from the innovations of Barkley Hendricks. He's had a bigger impact— for good or bad—on where we are today than almost any other artist I can think of. But his voice and the way that he front-faces the Black body, how he positions it, oftentimes in the center of the frame, kind of glaring back and engaged— particularly in the years that the Frick exhibition focuses on—is instrumental to where we're at now. This is an opportunity to really see art history, and not every exhibition gives you that chance.

As told to Antwaun Sargent

Barkley L. Hendricks, *Brilliantly Endowed*, 1977. Oil and acrylic on canvas, 66 × 48 in. (167.6 × 121.9 cm). Rennie Collection, Vancouver

Rashid Johnson, *Self-Portrait in Homage to Barkley Hendricks*, 2005. Inkjet print on white PolyFilm, 74 × 56 in. (188 × 142.2 cm). Courtesy the artist

Fahamu Pecou

ONE'UH MY HEROES

They say "never meet your heroes" . . . But nah, fuck that!

Back in 2016, when the Nasher Museum of Art at Duke University acquired my tribute to Barkley Hendricks called *Nunna My Heroes*, I was thrilled. Even more so, when I learned that the painting would hang next to its referent, Barkley's *Icon for My Man Superman* (see fig. 32), in the group exhibition *Southern Accent*! But when I heard that Barkley would be attending the opening of the show, my emotions were somewhere beyond ecstatic.

I first learned about Barkley's work three years earlier. After I returned home from a residency in South Africa in 2008, several friends told me about him and an exhibition of his work that I needed to see. Curiously, they wouldn't tell me much except that I needed to see it.

Birth of the Cool was Barkley's seminal retrospective and, in many ways, signaled his revival in the contemporary art world. Entering the galleries of that show at the Nasher, I was immediately seized by his striking portraits of casual Black beauty, style, and grace. Much of the work was from the 1960s and '70s. With their newsboy caps, flowing trench coats, bell-bottom jeans, platform shoes, afros, swagger, and soul, his paintings were unapologetic in their representation of the era of Black Power and Black Is Beautiful. His subjects were magnificently composed, regal, and rendered to the highest artistic standards. Barkley's colors and attention to the most minute of details kept me rapt. I studied every stroke, attempting to track the movement of his hand across the canvases. I had not seen work like this before, fine art that centered on and elevated what some might consider a "ghetto" aesthetic.

Barkley was not altering his subjects to appeal to the Rockwellian sensibilities that reigned supreme in some quarters during the 1960s. These works were as defiant as they were beautiful, subtly rejecting any notion of inferiority or classism. His aesthetic resonated with me. For years, I had been broaching this idea in my work. My paintings featured the swag and bravado of the hip-hop generation, using paint on canvas to subvert expectations and destabilize long-held stereotypes about Black men. In Barkley's work, I saw myself—in the way a son might recognize that he has his father's walk. Throughout my interrogation of contemporary Black male subjectivity, I sought to depict Black life and lifestyles as pure and as authentic to the Black experience as possible. Through Barkley Hendricks, I saw that it could not only be done but that it could be done without any compromise in the artistic process.

* * *

The night of the opening of *Southern Accent*, I lingered in my Durham hotel, trying to summon the courage (and conversation) to engage my hero. After more than an hour of pep-talking myself, I made my way to the Nasher. I still wasn't quite sure what I would say when I finally had the chance to meet Barkley, but I knew at the very least I just had to shake his hand. When I entered the building, it was already buzzing with energy. A cursory scan around the room revealed several familiar faces engaged in hugs, smiles, and various decibel levels of conversation. Still nervous, I needed a drink. I spotted a bar and headed straight for it. I took a few steps into the crowd of artists, curators, and patrons, and there, right in front of me, was Barkley chatting with the exhibition's curator, Trevor Schoonmaker. My heart began to race even more. I approached gingerly, reaching out my hand, "Hi, Mr. Hendricks, my name is . . ." Before I could finish, he grabbed my hand and embraced me. "I know who you are, young brother. And I love what you do!" I must have emerged from the embrace with a shocked look on my face. "Keep up the great work, brother . . . and you can call me Barkley." After a

few more pleasantries and a couple of photos, I finally made it to the bar. I really needed a drink now! Nerves easing, I noticed the woman in front of me shared a warm smile. "Are you having a good time this evening?" she asked. "Yes, ma'am," I said. "I just met my HERO Barkley Hendricks!" "Oh, he puts his pants on one leg at a time, just like everybody else. Trust me, I know. He's my husband." Susan Hendricks laughed coolly, and so did I.

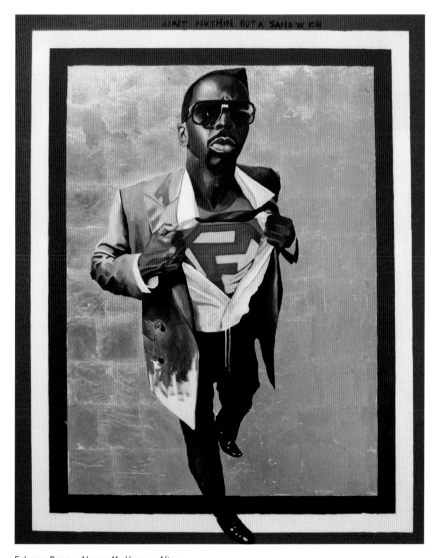

Fahamu Pecou, *Nunna My Heroes: After Barkley Hendricks' "Icon for My Man Superman," 1969*, 2011. Acrylic, gold leaf, and oil stick on canvas, 63 × 49½ in. (160 × 125.7 cm). Nasher Museum of Art at Duke University, Durham; Gift of Marjorie (P'16, P'19, P'19) and Michael Levine (B.S.'84, P'16, P'19, P'19)

Mickalene Thomas

IN THE SPIRIT OF BLACKNESS

A lot of my work is in conversation with Barkley Hendricks. *I Can't See You Without Me* (2006), a painting I made for one of my first big group exhibitions, comes to mind. It was shown at the Luggage Store Gallery, in San Francisco, alongside work by Titus Kaphar and Mark Bradford. There's also my photograph *Lovely Six Foota* (2007), where I started to think about Barkley and the compositions of his sitters, as well as the seduction and the sexuality. He was infatuated with women's feet in shoes. *Lovely Six Foota* references the height of a very tall, beautiful woman. Another is *Special Occasion* (2007). I love this painting because it exudes the sophistication, Blackness, style, and energy of Black people, particularly Black women, in a way similar to how Barkley captures and depicts Black people in his paintings. While I am not a painter like Barkley, I have an appreciation for painters like him and their skill and craftsmanship. He was an incredible artist.

I remember seeing a painting by Barkley in an exhibition at the New Museum in 2003, a year after I graduated from Yale. I had completed the artist-in-residence program at the Studio Museum in Harlem and had moved into a studio in downtown Brooklyn. I remember the excitement and energy of that show. Up until then, I had only seen his work in reproduction, but seeing it in person gave me a real sense of agency and validated me as a young Black artist.

At the time, I didn't know the power of my photographs. I accepted them as their own body of work and only recognized what was happening—the dynamic energy that was coming from the image—much later. I realized the power of my photographs, especially once people connected to them as the female subjects portrayed their prowess. Photography, even with its artifice, stands in the conversation as "truth." When you look at photographic images, the image comes closer to being a reality The familiarity of the subjects lends itself to personal history. So, for me, allowing the photographic images to be powerful enough on their own terms was a revelation, just as I imagine it was for Barkley. What I'm really proud of in my own photographic work is that it holds its discourse within its own audience. Barkley's photographs are very powerful and familiar in the ways he depicts Black life. For my photographs, it's more about rejuvenation and the reimagination of a particular nostalgia for Black life and Black women in particular spaces. I'm proud to say I own a Barkley Hendricks photograph; unfortunately, though, it's my only work of his—I wish I had more. The title of the photograph is *Pretty Eyes—Among Other Things* (1976). The image is of a naked Black woman, reclining in a way similar to the figure in *I Can't See You Without Me* (2006). She has short hair, with an afro, and she's kind of butch or boyish looking. She has a hard femininity rather than a soft one, but she's beautiful, dark-skinned, sexy, and naked—relaxed and comfortable. Her gaze is unapologetic, as though she's aware of being looked at, of what she's doing, and taking ownership of her own prowess. Her gaze is fixed and centered, and her message to the viewer is, "Look at me." When you look closely, however, you see that there's this strange white line between her legs, perhaps the string of a tampon. There's no blood or anything. For me, this allusion to a woman's menstrual cycle is uncanny and somewhat unusual, almost forbidden—no one really talks about this. It is a highly suggestive, a powerful, subtle suggestion of female reproduction and sexuality and sexiness for some people. It seems so radical. I love this photo because it provides such an awareness of the female body; I had never imagined the possibility of shifting the narrative in photography in such a subtle and provocative way, but this image is loaded and shows how you can put information in your photographs, your paintings, and how it can lend itself to various narratives. I love it—so impactful, suggestive, and provocative.

Barkley loved women, and he let you know that in every way. I loved that about him. He loved to paint, and he especially loved to paint and photograph Black people. He walked around with his camera all the time. I feel so privileged to have been in his presence during his lifetime and to have witnessed some of his challenges, his growth, and the success he enjoyed as someone who simply never stopped making art.

Like Barkley, I have been influenced in my work by a particular period of Black history—the civil rights movement, the politics around Black Is Beautiful, the Black women's movement, the conversation around beauty, hair, clothes, style, hipness, and everything they encompass. The materiality in my work represents a time when certain groups of women and collectives—such as "Where We At" Black Women Artists, Inc., a group established in 1971 by fourteen Black female artists working in various mediums— were making use of materials that seemed to be nontraditional or outsider.

A Harlem fashion show, known as *Naturally '62*, also helped start the Black Is Beautiful movement; meanwhile, the African Jazz-Art Society and Studios was founded to promote African culture and fashion. The women were all dark-skinned, had natural, unprocessed hair, and they called themselves Grandassa Models. They radically shifted contemporary social ideas in art in the same way that many Black women were choosing to wear afros during the Black Power movement. So, for me, this was a way of bringing these materials that were not always part of the Western canon into the conversation. By choosing these nontraditional materials, I'm making a radical statement as an artist, as the Black female collectives did in the '60s and '70s.

When Barkley gold-leafs his work, as he did the background to the afro in *Lawdy Mama* (cat. 1), it elevates him beyond the notions and stereotypes of what we know of him because it fuses the Western art-historical canon with Black excellence, elevating us as archetypes, royalty, goddesses. This is another way to say, "Black is beautiful," to embrace the legacy of Black culture, and to expand upon our cultural pride and achievements. For me particularly, putting my Black women in afros was not only a sign of resistance but also a way of stating,

"This is not just a style; this is about deeming ourselves beautiful."

The legacy of Barkley's portraiture is so relevant today. Black portraiture is about the desire to see ourselves in images. All over the world, Black people are depicting themselves and their moments and stories of Black leisure, Black love and Black joy. I think a lot of that has its roots in Barkley. Barkley is to portraiture and figuration as Jean-Michel Basquiat is to pop culture, pop art, and abstraction. As a Black portraitist, he is, for me, that quintessential, iconic artist. You cannot talk about American figurative painting, especially Black American portraiture, without including Barkley Hendricks. That is his legacy.

As told to Antwaun Sargent

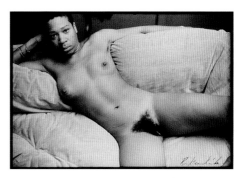

Barkley Hendricks, *Pretty Eyes—Among Other Things*, 1976. Silver gelatin print. 4½ × 6½ in. (11.4 × 16.5 cm). Private collection

Mickalene Thomas, *I Can't See You Without Me*, 2006. Rhinestones, acrylic, and enamel on wood panel, 72 × 72 in. (182.9 × 182.9 cm). Private collection

Kehinde Wiley

TABULA RASA

No figurative artist can approach painting without considering Barkley Hendricks. As a Black male artist from the West Coast, I belong to a long line of artists who had to contend with the question of figurative work versus abstraction and its political significance. When I first stepped into the creative milieu, there was a privileging of conceptual works and abstraction with the idea that it offered a type of real intellectual content—one wherein "difficulty," as an aesthetic component, became the leading edge of a visual language that privileged white, male artists. It was difficult to find diverse voices. The exceptions were Kerry James Marshall, Robert Colescott, and of course, Barkley Hendricks.

My first introduction to Barkley was in studying figurative work at Yale. It was there that I began looking at the body language and gestures of the aristocratic class in Western European easel paintings. I became obsessed with decoding the language of power codified within them that expressed a very specific vocabulary of domination: an ease of power and a sense of facile authority over land, women, and the self. Barkley's interpretation of that very same vocabulary of stateliness and possession inspired me. When looking at his work, I saw a language of grace bifurcated between a familiar, everyday Black vernacular body language and a very tightened, self-conscious awareness. It vacillated between what one might call extreme posing and the lived experience of passing through space. That inspired a body of work called *Passing/Posing* (ca. 2000) in which I explored the ways that body language, and consequentially painting, is sometimes hyper-constructed versus the ways in which people naturally position themselves in my studio or when they are photographed unaware that the camera is involved.

I think Barkley's primary obsession had to do with minimizing the components within the picture plane, reducing the landscape to a sheer color swatch, removing the distinction between landowner and land, the possessed versus the possessor. This reduces the field to a tabula rasa, an ideal form in which one can fashion one's identity without the interference of history, in which anything is possible. He positions a type of impossibility in which one can imagine oneself both within and outside of history, creating a compelling tension between the desire to be seen as fully autonomous and the anxiety of influence that history carries upon all of us. Simply placing a Black body within space says a lot already.

In the 1970s, Barkley began removing color from the picture plane in what would become his "limited palette" series, which occupy a really charged space because he was literally placing the Black body within a white space. Here not only is the field devoid of nature or interior or still life, but it also becomes void of color itself. The juxtaposition between Black skin and white space becomes at once a neutral and hyper-politicized moment. The Black sitter is seen dominating the space, cocooned within a field of whiteness that appears comforting and threatening all at once. Barkley is not simply playing with a monotone; rather he is using whiteness as a study of oppositional and congruent color pairings to explore the two-dimensionality of Blackness in society. The radical idea here is that by reducing elements in the composition, he's allowing the viewer to explore the complexities of the human beings pictured within the frame.

You could argue that the white space is a stand-in for a white body politic. It brings in all the baggage from Barkley's prior bodies of work but now takes on more complexity in that it becomes a question of, "How comfortable is that space? How does that space claim you? Do you belong to that space? Is it something that you can thrive in?"

I explored similar questions in my recent body of work, *Prelude* (2021), by building upon the narrative of whiteness as a field that is at once a site of shelter and disaster. The invention of whiteness as a racial category pervades the exploration of nature, especially shot through the lens of naturalist painters such as Caspar David Friedrich. In this body of work, I used whiteness

as a kind of metaphor, employing snow and ice as a means to flatten color so that black and white become binary poles, begging the viewer to reconsider assumptions about both. Through a radical reduction in his use of color and spatial composition, and the way that we receive Blackness, Barkley encouraged all of us to see the full range of possibilities that we as artists are capable of producing within the broader evolution of culture.

Still from Kehinde Wiley's *Prelude*, 2021.
Six-channel digital film

Bibliography

Albany 2006
Represent: Selections from the Permanent Collection of the Studio Museum in Harlem. [No exh. cat.] Albany (New York State Museum), 2006.

Arabindan-Kesson 2016
Arabindan-Kesson, Anna. "Portraits in Black: Styling, Space, and Self in the Work of Barkley L. Hendricks and Elizabeth Colomba." *Nka*, nos. 38–39 (2016): 70–79.

Arabindan-Kesson 2017a
Arabindan-Kesson, Anna. "Surface and Style: Family Jules and 1970s Aesthetics." In *Family Jules: No Naked Niggahs 1974 by Barkley L. Hendricks for Tate In Focus*, September 2017. https://www.tate.org.uk/research/in-focus/family-jules/surface-and-style.

Arabindan-Kesson 2017b
Arabindan-Kesson, Anna. "Iconic Portraits: Revising the Canon." In *Family Jules: No Naked Niggahs 1974 by Barkley L. Hendricks for Tate In Focus, September 2017.* https://www.tate.org.uk/research/in-focus/family-jules.

Arabindan-Kesson 2017c
Arabindan-Kesson, Anna. "The Painting." In *Family Jules: No Naked Niggahs 1974 by Barkley L. Hendricks* for *Tate in Focus*, September 2017. https://www.tate.org.uk/research/in-focus/family-jules/the-painting.

Bellenger 2005–7
Bellenger, Sylvain. "Les droits de l'homme et du citoyen." In *Girodet 1767–1824*, 322–35. Exh. cat. Paris (Musée du Louvre), Chicago (Art Institute of Chicago), New York (Metropolitan Museum of Art), and Montreal (Musée des Beaux-Arts de Montréal), 2005–7.

Belsey 2019
Belsey, Hugh. *Thomas Gainsborough: The Portraits, Fancy Pictures, and Copies after Old Masters.* 2 vols. New Haven, 2019.

Boston 1975–76
Edmund Barry Gaither. *Jubilee: Afro-American Artists on Afro-America.* Exh. cat. Boston (Museum of Fine Arts), 1975–76.

Bridgeport 1988
Barkley L. Hendricks Presents Barkley L. Hendricks. Exh. cat. Bridgeport (Housatonic Museum of Art), 1988.

Brooklyn, Hanover, and Austin 2014–15
Teresa A. Carbone et al. *Witness: Art and Civil Rights in the Sixties.* Exh. cat. Brooklyn (Brooklyn Museum of Art), Hanover (Hood Museum of Art), and Austin (Blanton Museum of Art), 2014–15.

Brunswick 2017
Barkley Hendricks: "Let's Make Some History." [No exh. cat.] Brunswick (Bowdoin College Museum of Art), 2017.

Cambridge 2017–22
32Q: 3620 University Study Gallery. [No exh. cat.] Cambridge (Harvard Art Museums), 2017–22.

Canavan 2008
Canavan, Gerry. "Barkley L. Hendricks in Durham for His First Career Retrospective." *INDYweek*, February 6, 2008. https://indyweek.com/culture/art/barkley-l.-hendricks-durham-first-career-retrospective/.

Chicago 2000
Color: The Chicago Black Fine Art Exposition. Exh. cat. Chicago (Navy Pier), 2000.

Copeland 2009
Copeland, Huey. "Figures and Grounds: The Art of Barkley L. Hendricks." *Artforum*, April 2009. https://www.artforum.com/print/200904/figures-and-grounds-the-art-of-barkley-l-hendricks-22305.

Dunkerton 2011
Dunkerton, Jill. "Leonardo da Vinci: Pupil, Painter and Master." *National Gallery Technical Bulletin* 32 (2011): 4–31.

Durham and other cities 2008–10
Trevor Schoonmaker, ed. *Birth of the Cool.* Exh. cat. Durham (Nasher Museum of Art), New York (Studio Museum in Harlem), Santa Monica (Santa Monica Museum of Art), Philadelphia (Pennsylvania Academy of the Fine Arts), and Houston (Contemporary Arts Museum), 2008–10.

Fairfield 1978
The Southern New England Invitational Art Exhibition 1978. [No exh. cat.] Fairfield (Fairfield University), 1978.

Genocchio 2008
Genocchio, Benjamin. "Pop Art Meets Photorealism." *The New York Times*, January 27, 2008. https://www.nytimes.com/2008/01/27/nyregion/nyregionspecial2/27artsubct.html.

Greenville, Charleston, and Columbia 1975
Barkley L. Hendricks: Recent Paintings. Exh. cat. Greenville (Greenville County Museum of Art), Charleston (Gibbes Art Gallery), and Columbia (Columbia Museum of Art), 1975.

Hampstead 1983
Eleanor Flomenhaft. *Celebrating Contemporary American Black Artists.* Exh. cat. Hampstead (Fine Arts Museum of Long Island), 1983.

Hartford 1983
Connecticut Artists Showcase. [No exh. cat.] Hartford (Connecticut Commission on the Arts), 1983.

Hartford 2002
Hairitage. [No exh. cat.] Hartford (Wadsworth Atheneum), 2002.

Hendricks 2008–10
Hendricks, Barkley L. Interview by Thelma Golden. In Durham and other cities 2008–10, 59–77.

Hendricks 2009
Hendricks, Barkley L. Interview by Kathy Goncharov. Archives of American Art, Smithsonian Institution, June 18, 2009.

Hendricks 2016a
Hendricks, Barkley L. "Barkley L. Hendricks – 'I Want to Be Memorable' | TateShots." Tate, July 28, 2016. YouTube video. https://youtu.be/VlRHKivQCqw.

Hendricks 2016b
Hendricks, Barkley L. "Artist Talk: Barkley L. Hendricks." Art Institute of Chicago, October 19, 2016. YouTube video. https://youtu.be/wfR2FxDnDO0.

Hurston 1928
Hurston, Zora Neale. "How It Feels to Be Colored Me." *The World Tomorrow* 11 (May 1928): 215–16.

Knight 2009
Knight, Christopher. "Barkley L. Hendricks at the Santa Monica Museum of Art." *Los Angeles Times*, May 25, 2009.

Kramer 1977
Kramer, Hilton. "Art: To the Last Detail." *The New York Times*, June 17, 1977.

Lerner 2016
Lerner, Ben. "The Custodians: How the Whitney Is Transforming the Art of Museum Conservation." *The New Yorker*, January 11, 2016.

London and other cities 2017–20
Mark Godfrey and Zoé Whitley, eds. *Soul of a Nation: Art in the Age of Black Power*. Exh. cat. London (Tate Modern), Bentonville (Crystal Bridges Museum of American Art), New York (Brooklyn Museum), Los Angeles (The Broad), San Francisco (de Young, Fine Arts Museums of San Francisco), and Houston (Museum of Fine Arts), 2017–20.

London and Walsall 2005
Richard J. Powell et al. *Back to Black: Art, Cinema & the Racial Imaginary*. Exh. cat. London (Whitechapel Gallery) and Walsall (New Art Gallery Walsall), 2005.

London and Washington 2022
Margaret F. MacDonald et al. *The Woman in White: Joanna Hiffernan and James McNeill Whistler*. Exh. cat. London (Royal Academy of Arts) and Washington (National Gallery of Art), 2022.

Loretto, Erie, and Doylestown 2001
Michael A. Tomor, John Vanco, and Bruce Kastiff. *Artists of the Commonwealth: Realism in Pennsylvania Painting, 1950–2000*. Exh. cat. Loretto (Southern Alleghenies Museum of Art), Erie (Erie Art Museum), and Doylestown (James A. Michener Art Museum), 2001.

Madin 2006
Madin, John. "The Lost African: Slavery and Portraiture in the Age of Enlightenment." *Apollo* 164, no. 534 (August 2006): 34–39.

Mangan 1976
Mangan, Dorothy. "Barkley Hendricks and His Figurative Drama." *American Artist* 40 (July 1976): 34–38, 68–70.

Mannings 2000
Mannings, David. *Sir Joshua Reynolds: A Complete Catalogue of His Paintings*. 2 vols. New Haven, 2000.

Murphy 1983
Murphy, Tim. "Barkley Hendricks: More Doer than Dewar's." *The Day*, May 1, 1983.

Neal 1968
Neal, Larry. "The Black Arts Movement." *Drama Review* 12, no. 4 (Summer 1968): 28–39.

New Haven 1985
Carol Anthony. *15 Painters + 15 Sculptors*. Exh. cat. New Haven (John Slade Ely House), 1985.

New London 1973
Connecticut College Faculty Art Exhibition. [No exh. cat.] New London (Connecticut College Galleries), 1973.

New London 1991
The Artist Sees New London. [No exh. cat.] New London (Lyman Allyn Art Museum), 1991.

New London 2001
The Barkley L. Hendricks Experience. Exh. cat. New London (Lyman Allyn Art Museum), 2001.

New London 2011
Face Off: Portraits by Contemporary Artists. [No exh. cat.] New London (Lyman Allyn Art Museum), 2011.

New Orleans 2017–18
Trevor Schoonmaker and William Cordova. *Prospect.4: The Lotus in Spite of the Swamp*. Exh. cat. New Orleans (New Orleans Museum of Art), 2017–18.

New York 1976
Barkley Hendricks: Exhibition of Paintings. Exh. cat. New York (ACA Galleries), 1976.

New York 1977
Four Young Realists: Anne Besser, Rebecca Davenport, Barkley Hendricks, Mark Rendelman. Exh. cat. New York (ACA Galleries), 1977.

New York 1980
Mary Schmidt Campbell. *Barkley L. Hendricks: Oils, Watercolors, Collages, and Photographs*. Exh. cat. New York (Studio Museum in Harlem), 1980.

New York 1994–95
Thelma Golden. *Black Male: Representations of Masculinity in Contemporary American Art*. Exh. cat. New York (Whitney Museum of American Art), 1994–95.

New York 2005
The Whole World Is Rotten: Free Radicals and the Gold Coast Slave Castles of Paa Joe. [No exh. cat.] New York (Jack Shainman Gallery), 2005.

New York 2016–17
Human Interest: Portraits from the Whitney's Collection. [No exh. cat.] New York (Whitney Museum of American Art), 2016–17.

New York 2017
Regarding the Figure. [No exh. cat.] New York (Studio Museum in Harlem), 2017.

Norfolk 1980
Thomas W. Styron. *American Figure Painting, 1950–1980*. Exh. cat. Norfolk (Chrysler Museum), 1980.

Norfolk 2001
Work of the Month. [No exh. cat.] Norfolk (Chrysler Museum), 2001.

Norfolk 2012
Remix Redux: A Fresh Mix for Our Modern and Contemporary Galleries. [No exh. cat.] Norfolk (Chrysler Museum), 2012.

Pedro 2016
Pedro, Laila. "In Conversation: Barkley L. Hendricks with Laila Pedro." *The Brooklyn Rail*, April 2016. https://brooklynrail.org/2016/04/art/barkley-l-hendricks-with-laila-pedro.

Philadephia 1969
Randall J. Craig. *Afro-American Artists, 1800–1969*. Exh. cat. Philadelphia (Philadelphia Civic Center), 1969.

Philadelphia 1974
The Second World Black Art and African Festival of Art and Culture, Inc., North American Zone, Southeastern Regional Exhibition. [No exh. cat.] Philadelphia (University Museum), 1974.

Philadelphia 1992
Sande Webster and Barbara Wallace. *"First in the Heart Is the Dream": African-American Artists in the 20th Century*. Exh. cat. Philadelphia (Philadelphia Art Alliance), 1992.

Philadelphia 2015
Gwendolyn DuBois Shaw and Richard J. Powell. *Represent: 200 Years of African American Art in the Philadelphia Museum of Art*. Exh. cat. Philadelphia (Philadelphia Museum of Art), 2015.

Philadelphia 2021
Painting Identity. [No exh. cat.] Philadelphia (Philadelphia Museum of Art), 2021.

Powell 2008
Powell, Richard J. *Cutting a Figure: Fashioning Black Portraiture*. Chicago, 2008.

Powell 2008–10
Powell, Richard J. "Barkley L. Hendricks, Anew." In Durham and other cities 2008–10, 39–57.

Raynor 1982
Raynor, Vivian. "Art: Barkley Hendricks, a Tale of Two Artists." *The New York Times*, March 26, 1982.

Roxbury 1980
Edmund B. Gaither. *Spiral: African American Art of the 70s*. Roxbury (National Center of Afro-American Artists), 1980.

Salmon 2010
Salmon, Lori Louise. "Stand Up Next to a Mountain: The Art of Barkley L. Hendricks, 1964–77." MA thesis, Stony Brook University, 2010.

San Francisco and other cities 2019–21
Connie H. Choi, Thelma Golden, and Kellie Jones. *Black Refractions: Highlights from The Studio Museum in Harlem*. Exh. cat. San Francisco (Museum of the African Diaspora), Charleston (Gibbes Museum of Art), Kalamazoo (Kalamazoo Institute of Arts), Northampton (Smith College Museum of Art), Salt Lake City (Utah Museum of Fine Arts), and Seattle (Frye Art Museum), 2019–21.

Sargent 2017
Sargent, Antwaun. "The Obamas and the Inauguration of Black Painting's New Golden Age in America." *W* magazine, October 30, 2017. https://www.wmagazine.com/story/barack-michelle-obama-kehinde-wiley-amy-sherald-black-portrait-artists.

Sargent 2019
Sargent, Antwaun. *The New Black Vanguard: Photography between Art and Fashion*. New York, 2019.

Schoonmaker 2008–10
Schoonmaker, Trevor. "Birth of the Cool." In Durham and other cities 2008–10, 15–37.

Thomas 2018
Thomas, Mickalene. "Le déjeuner sur l'herbe: Les trois femmes noires." *Figuring History*, Seattle Art Museum, 2018. https://figuringhistory.site.seattleartmuseum.org/mickalene-thomas/le-dejeuner-sur-lherbe-les-trois-femmes-noires/.

Thorpe 2020
Thorpe, Vanessa. "Is it time the art world ditched the term 'old master'?" *Guardian*, June 27, 2020.

Valentine 2019
Valentine, Victoria L. "Backstory: Art Collector Kenneth Montague on Acquiring 'Blood (Donald Formey),' the 1975 Painting by Barkley L. Hendricks." *Culture Type*, February 3, 2019. https://www.culturetype.com/2019/02/03/backstory-art-collector-kenneth-montague-on-acquiring-blood-donald-formey-the-1975-painting-by-barkley-l-hendricks/.

Waltham 2022
Gannit Ankori. *My Mechanical Sketchbook: Barkley L. Hendricks & Photography*. Exh. cat. Waltham (Rose Art Museum), 2022.

Whitley 2017–20
Whitley, Zoé. "American Skin: Artists on Black Figuration." In London and other cities 2017–20, 193–225.

Whitley forthcoming
Whitley, Zoé, ed. *Barkley L. Hendricks: Solid!* Vol. 5. New York, forthcoming.

Index

Image Credits

This catalogue is published on the occasion of *Barkley L. Hendricks: Portraits at the Frick*, an exhibition on view at The Frick Collection, New York, from September 21, 2023, to January 7, 2024. The catalogue is funded, in part, by Ayesha Bulchandani. The exhibition is made possible with support from the Ford Foundation. Additional funding is generously provided by Margot and Jerry Bogert, Bain Capital, Ayesha Bulchandani, Agnes Gund, the Cheng-Harrell Institute for Global Affairs, Jane Richards, Arielle Patrick, and an anonymous donor.

First published in the United States of America in 2023 by

Rizzoli Electa
A division of Rizzoli International Publications, Inc.
300 Park Avenue South
New York, New York 10010
rizzoliusa.com

Publisher: Charles Miers
Associate Publisher: Margaret Chace
Senior Editor: Philip Reeser
Production Manager: Alyn Evans
Design Coordinator: Olivia Russin
Managing Editor: Lynn Scrabis

in association with

The Frick Collection
1 East 70th Street
New York, New York 10021
frick.org

Editor in Chief: Michaelyn Mitchell
Associate Editor: Christopher Snow Hopkins

Designer: Morcos Key

ISBN: 978-0-8478-7359-3
Library of Congress Control Number: 2023931011
A CIP catalogue record for this book is available from the Library of Congress.

2023 2024 2025 2026 / 10 9 8 7 6 5 4 3 2 1

Printed in Hong Kong

Cover: cat. 10
Frontispiece: detail of cat. 12
Pages 136–37: detail of cat. 10